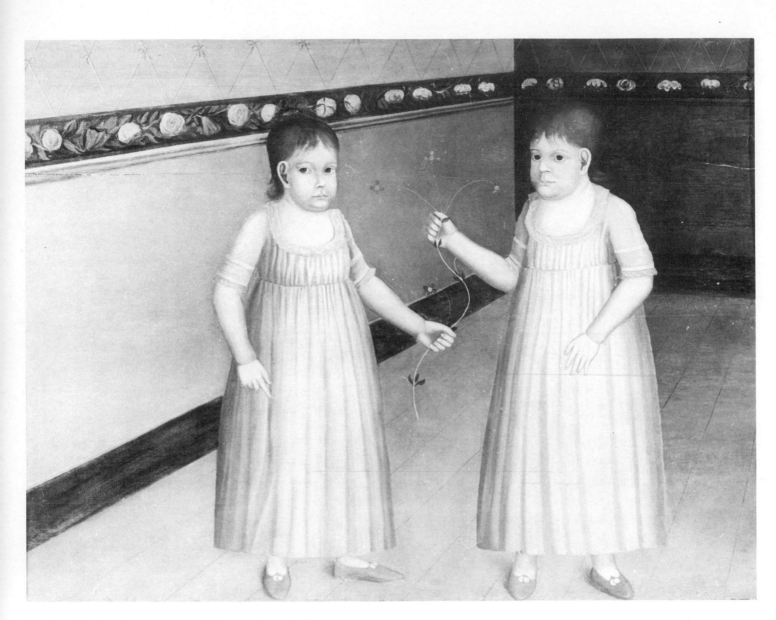

Unidentified twins in room which may have had
painted walls. Artist not known. Photo courtesy
Carl Crossman.

BORDERS & SCROLLS

Early American Brush-Stroke Wall Painting
1790-1820

by

Margaret Coffin
For
Albany Institute of History and Art

Foreword by Philip Parr

Drawings of houses by Marjorie B. Clarke

Replicas of original painting and
illustrative drawings by the author

Cover: Motif from Beach Tavern parlor.
Courtesy Gene and Mary Burlingham.

Founded in 1791, the Albany Institute of History
& Art is dedicated to collecting, preserving,
interpreting, and promoting an interest in the
history, art, and culture of Albany and the Upper-
Hudson Valley Region. The museum achieves this
mission through its collections, exhibitions,
education programs, library, research projects,
publications and other programs offered to the
general public.

© 1986 Albany Institute of History and Art
ISBN # 0-939072-08-4
Printed by Lane Press of Albany, Inc.

for
JOSH and JED
SARAH, ERIN MARGARET and CLEA

Acknowledgments

I wish to acknowledge the help of many old friends and acquaintances and of many people who became new friends because of our mutual interest in recording the story of these painted walls. I am more than grateful to my photographer, my husband Charles, for his encouragement and assistance in creating the text and illustrations for this book. My deep appreciation goes to: Jessica Bond, Nina Little and Gina Martin, who have, for some time, been interested in early wall decoration; Betty Jane Baxter, Ronald J. Burch, William Jenney, Sally Brillon, Shirley Dunn, Rosa Johnston, Norma Stark, Louise Dodge, Anita Smith and Susan Hayes, who aimed me toward painted-wall houses I might not have found myself; Rosemary Zullo, Charlie Jakiela, Iris and Harold Roth, Barbara and Peter Goodman, Margaret and Howard Bigelow, Marjorie and the late Ranney Galusha, Marjorie Clarke, Dr. and Mrs. Mannucio Mannucci, Joan and Richard Arms, Mary and Gene Burlingham, Mr. and Mrs. Richard Dorsey, Alice and John Kiablick, Mr. and Mrs. David Newell, Sam Swanson, Mr. and Mrs. John Woods, Sharon and Bill Palmer, Eleanor and Benjamin Campney, all of whom have known these houses more intimately than I; fellow decorators Phyllis Sherman, Doris Fry, Lois Trieb; Christopher Merritt of Sagamore Hill; Carol Kohan, Bruce Stewart and Linda Mazur of the Martin Van Buren National Historic Site; John Scherer of the New York State Museum; John C. Curtis of Old Sturbridge Village; Charles Ritchie of the National Gallery of Art; Mrs. Meek of the Cheshire Historical Society; Robert Egelston of New Haven Colony Historical Society; Albert Gamon of Peter Wentz Farmstead and Betty McClave; Bernice Knight, Carl Crossman, Betty Day, Don Carpentier, Helen Anderson, Phyllis Burbank, Elsie Scott, Katherine Burgess, Ruth Piwonka and Lillian D. Tallman. I am very grateful to my friend Philip Parr, who has spent years searching out information concerning stenciled wall decoration in western New York State and is responsible for the fine exhibit during 1985 in the Rochester Museum and Science Center. Mr. Parr steered me to Beach Tavern, then generously shared his tracings and slides of Tavern walls with me. Thank you, also, Agnes Williams.

My especial appreciation is extended to Dr. Roderic Blackburn, Joseph Reeves and Clare Oswald Weber of the Albany Institute of History and Art, who, respectively, suggested, encouraged and shepherded this project to fruition; to Nina Fleishman for her editorial assistance; and to Marjorie Clarke, whose drawings of houses help us to picture them as the decorators saw them. I extend my thanks also to Bob Luther and Traci Kaso of Lane Press.

Foreword

It can be argued that there have been only two architectural styles in the history of western civilization (at least until the 20th century), namely, Classic and Gothic. The Classic style is based on the principles developed by the ancient Greeks. It is characterized by a horizontal emphasis and features regularity and symmetry. At various times it has been called Renaissance, Baroque, Rococo, Georgian, Greek Revival, and Classical Revival.

The Gothic style originated in central Europe in the 11th century. It is distinguished by a vertical emphasis and generally by studied irregularity, a quality the Victorians called "picturesque." This style was particularly popular in the United States in the last half of the 19th century.

Since humans prefer variety and change, sometimes one style was favored, to be replaced later by the other. It is interesting to observe that whatever the differences between the two styles, both have utilized wall painting for interior decoration.

This book is devoted to a discussion of a particular type of wall painting which was popular in a small area of the United States around the turn of the 19th century. It fits comfortably within the traditions of the "Age of Classicism," which held Europe and America in its fashion grip for the hundred years between 1750 and 1850.

The Age of Classicism, which in many respects established the appearance and character of the infant United States, pervaded every aspect of life. It obviously influenced architectural styles, but it also affected art, poetry, music, dress, and politics. (Our government is, of course, modeled on the Roman republic.)

The Age of Classicism can be roughly divided into three periods, all springing from the same classical tradition, despite their superficial differences. The style of the first period, which lasted from 1750 until about 1775, was bold, robust and masculine. It is typified by Georgian architecture and Chippendale furniture. The style of the second period, which ran from about 1765 to 1830, was greatly influenced by the discoveries in Pompeii and had an attenuated, feminine appearance. It is represented by post-Colonial (Federal) architecture, Hepplewhite and Sheraton furniture, and Adam decoration. The last period, from 1810 to 1850, featured a return to the massive, substantial style. Architecture was termed Greek Revival, and the furniture was Empire.

Since we are interested in freehand wall painting from about 1790 until perhaps as late as 1820, it would be instructive to examine the second period of the Age of Classicism in order to determine the influences on this charming decoration. In particular, we would like to know why the walls were painted, what influenced the designs, and why the technique was abandoned.

The ancient Roman cities of Herculaneum and Pompeii were covered by a volcanic eruption in 79 A.D. In the early 18th century the cities were accidentally discovered under twelve feet of volcanic ash and mud, and in 1738 extensive excavations were begun. By the last quarter of the century, the results of these findings were known throughout the world. The cities had been miraculously preserved, and the interior decorations in particular were largely undamaged. The Romans had painted compositions on their walls. Some depicted fanciful scenes, but in other instances the walls had been treated as a single sheet of color overlaid with delicate, somewhat fussy designs. This approach to interior decoration appealed to 18th century Europeans and Americans. Two men in particular promoted a "new look" based on the Pompeian designs.

Michelangelo Pergolesi, an Italian artist, published a number of copperplate designs of classical-style ornaments between 1772 and 1792. They illustrate floral wall and ceiling decorations, friezes, panels and wreaths in a most light and graceful rococo manner. These designs were not usually direct copies of Pompeian decorations, but they were influenced by these discoveries. Pergolesi was a close friend of Robert Adam (1728-1792), the Scottish architect and decorator. Eventually Pergolesi joined Adam in London, where he lived the rest of his life. Adam's designs encompassed everything in a building—not only the exterior, but also the interior design and decoration, including the furniture. The themes he used became the hallmark of the new style: swags, pendants, palmettes, anthemion, wreaths, garlands, urns and vases. The essence of the approach was delicacy and lightness. Adam achieved his effects by employing fine artists to paint walls, doors, and ceilings with the Pergolesi designs.

Adam was hired to decorate the homes of the very rich in Britain. However, he could not personally attend to everyone, nor could everyone afford his prices. As always happens when demand outstrips supply, businessmen stepped in to furnish the desired commodity.

It was clear that there were not enough fine artisans to paint and decorate walls. The need was therefore satisfied by wallpaper, which gave approximately the same look. "Wallpaper is in the nature of a make shift: it is but a substitute for decoration of a more serious and substantial kind. No one would pretend that it has the dignity of wall painting."* This remark was published in 1892; imagine what people thought one hundred years earlier. Nevertheless, wallpaper was selected by the less affluent to decorate their homes.

It was not until the 1400s that paper mills were plentiful in Germany, France, and Italy. It was later in England. Wallpaper was soon introduced, and by the second half of the 18th century, wallpaper design and production were quite advanced. Popular patterns were produced in imitation of Pompeian wall paintings (or at least in that spirit) in order to compete with costly painted room decorations. Patterns were printed in water-based paint using wooden blocks, stencils, or freehand painting. Commonly, a combination of all three techniques was used. As the colors were likely to smear if touched with paste, wallpaper was usually installed by a professional craftsman, which added to the cost.

Although a wallpaper factory was established in Philadelphia in 1739, most papers in America were imported from France and England. However, trade with Europe was constantly interrupted by political turmoil, making supplies uncertain. Homeowners who did not live near the seacoast or on navigable rivers faced additional overland transportation charges which were especially steep.

For such reasons, wallpaper was generally too expensive for even prosperous middle-class farmers and merchants located on the frontier. These families were still fashion-conscious, however, and wanted to decorate their homes as near to the London and Paris ideal as their budgets would permit. The solution to the problem of wall decoration was provided by a small group of generally anonymous craftsmen who stenciled and freehand-painted walls for a reasonable fee. Since the desirable wallpaper was itself stenciled and freehand-painted, why not, it was reasoned, decorate directly on the wall?

Stenciling is an ancient craft and has always been used as a crutch to accelerate freehand painting. It was reintroduced as a wall decoration technique in about 1790, and was in favor until about 1840. Walls can be stenciled on the bare plaster without special preparation. The work can be accomplished quickly, and it requires no particular artistic talent. Thus, stenciling was a popular decorating technique in New England and on the western New York frontier. Stenciling, however, always results in a mechanical look which some find objectionable. Additionally, the desirable delicate and overall patterns cannot be rendered by stenciling; it is more suitable for widely-spaced, large, block-type patterns.

The objections to stenciling caused some homeowners to select freehand wall painting if there was an artisan available who was skilled in this higher form of art. The designs composed by these artisans are often remarkably similar in feeling to the wallpaper patterns they were attempting to match, although we know of no instance in which there was a deliberate attempt to copy.

Why did homeowners stop having their walls decorated in this delightful folk art form? There are probably three reasons. Throughout the 19th century, technical advances continuously reduced the cost of wallpaper, and in this country, improved transportation lowered carrying charges. Thus, wallpaper gradually became more affordable. Secondly, the finely-detailed and delicate post-Colonial architecture was being supplanted by the large, bold Greek Revival style of the third period. The fine brush strokes which characterized freehand wall painting did not seem to suit the big, high-ceilinged rooms of the new Greek style. Many Greek Revival walls were simply painted in plain colors. Also, although Mrs. Coffin has recently discovered many previously unrecorded brush-stroke-painted walls, it appears that few ornamental painters were skilled in this art.

Thus, the reign of freehand wall painting was short, bracketing the turn of the 19th century. Because it was largely confined to certain sections of New England and eastern New York, and in any event was never widely practiced, it is particularly important that what is known about the history and execution of freehand wall painting be thoroughly recorded for the benefit of the social and art historians. A glance through this book will show you a surprising range of absolutely delightful designs. The work of these unknown artisans can still touch our souls through the reach of nearly two hundred years. It is this which is the true value of Margaret Coffin's book.

Philip Parr

*Day, L., "Artistic Homes, The Choice of Wallpaper," *The Magazine of Art,* Cassell and Co., London, 1892.

Preface

Man has decorated walls throughout the ages and around the world. He has incised the stone in his caves and in his temples and left a heritage of painted walls in ancient cities. Architectural painting has long been popular in Central European countries, in Scandinavia, and in the Netherlands. In the Western Hemisphere, naive Indian wall painting may be found in Arizona, sophisticated gold leaf decoration in an early chapel in Three Rivers, Quebec, and remnants of elaborate stenciling in Spanish missions in New Mexico.

In Colonial and post-revolutionary America, three types of wall painting were practiced, especially in New England and New York: mural painting, stenciling, and brush-stroke painting—all in imitation of wallpaper. The formation of patterns using single strokes of a brush has long been practiced by painters of illuminated manuscripts, china, stoneware, tinware, furniture and vehicles. Examples of this kind of painting on existing walls, however, are rare; the discovery and recording of new specimens in different locations—New York State, western Massachusetts and Vermont—have added a chapter to the history of American wall painting.

This painting of birds, flowers and foliage on walls is usually precise, with patterns small in scale. Borders, sometimes created by brush strokes alone, are used along lines of construction: over baseboards and chair rails, at the top of walls and around door and window frames.

Most of these brush-stroke-painted walls were decorated about two hundred years ago. Some of the walls still standing have been exposed to weather and varied temperatures. Most have been papered over, and some, painted over. Many of the walls have, at some time during their existence, been covered in the process of "modernizing" or insulating a home. Only a few original walls are still in good condition. Photographs show the ravages of time and ill treatment.

This volume will discuss examples of brush-stroke-painted walls and the houses in which they have been found. Comparisons will be made to similar painting on stoneware, tinware, furniture, and wallpaper of the late 18th century, when much of this decoration was done. In some instances, original walls are illustrated; in others, replicas of the designs are shown to suggest the appearance of the walls when they were new.

Since I am not convinced of the names of specific wall painters, I have attributed two types of painting to the "Scroll Painter" and to the "Border Painter."

My first knowledge of brush-stroke wall painting, long before I had seen a painted wall of this type, came from two out-of-print books, Edward B. Allen's *Early American Wall Paintings* (Yale University Press, 1926) and Nina Little's *American Decorative Wall Painting* (Old Sturbridge Village and Studio Publications, 1952). In these sources the Waid-Tinker House and the H. W. Gray House (Fig. 14), both in Old Lyme, Connecticut, are described and illustrated. Designs used in these houses as friezes, dadoes, borders and overmantels echo paintings which I believe were done by the Scroll Painter (or a team which included the Scroll Painter) among the newly documented paintings found in New York State, western Massachusetts and Vermont.

Happy browsing!

Margaret Coffin

Illustrations

Contents

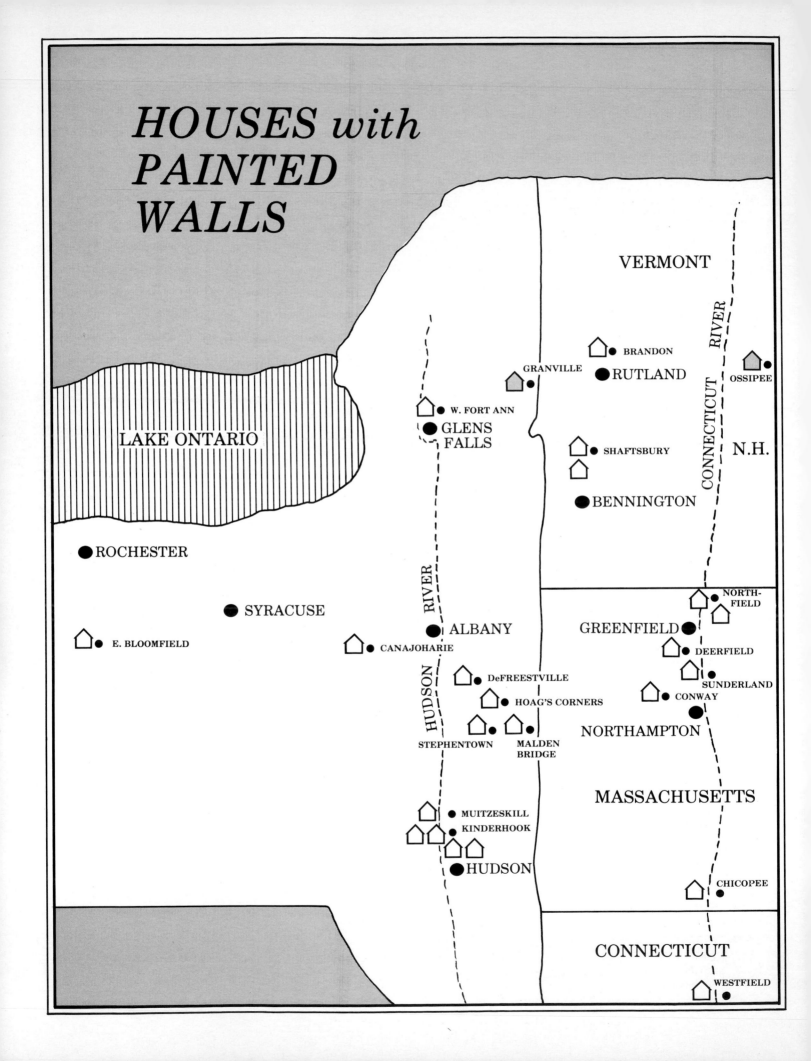

HOUSES with PAINTED WALLS

VERMONT

CONNECTICUT RIVER

BRANDON

GRANVILLE
RUTLAND

OSSIPEE

W. FORT ANN

N.H.

GLENS FALLS

SHAFTSBURY

BENNINGTON

LAKE ONTARIO

ROCHESTER

SYRACUSE

RIVER

NORTH-FIELD

GREENFIELD

E. BLOOMFIELD

ALBANY

CANAJOHARIE

DEERFIELD

SUNDERLAND

HUDSON

DeFREESTVILLE

CONWAY

HOAG'S CORNERS

NORTHAMPTON

STEPHENTOWN

MALDEN BRIDGE

MASSACHUSETTS

MUITZESKILL

KINDERHOOK

HUDSON

CHICOPEE

CONNECTICUT

WESTFIELD

Chapter 1

Types of Early Wall Painting in America

While freehand, brush-stroke painting "in imitation of wallpaper" is the main subject of this volume, two other types of wall painting—murals and stenciling—are probably more familiar to the reader.

MURAL PAINTING

Murals of European landscapes and figures, sometimes found over mantels, were among the early wall paintings that enjoyed a limited popularity in America during the 18th and early 19th centuries. These were almost always found in the homes of wealthy merchants and members of the professions along the Atlantic seaboard. Although some such paintings date from the beginning of the 18th century, they became most popular during the end of that century and beginning of the next. The earliest mural painters in America were Europeans.

CORNÉ

One example was Michel Felice Corné, a political refugee from Naples. In 1799 Corné found asylum aboard the ship Mount Vernon at anchor in Naples harbor. General Elias H. Derby, Commander of the ship, encouraged the artist to accompany him to the United States, where Corné settled for a time with the Derby family in Salem, Massachusetts. There, establishing his reputation, he painted tavern signs, landscapes and portraits. Several of his fireboards, marked "M. Corné Pinxit," are still in existence. Rather than painting his murals directly on plaster, Corné preferred painting on paper which was applied to the wall first, then decorated, or canvas, which was fastened to the wall by moldings after it was painted. Corné landscapes are most often pastoral, with thatched-roof cottages, detailed figures, and ships. The artist was fond of broad panoramic views. He worked in almost every medium, and when he was not painting, taught art classes for both adults and children. Corné once painted an Ipswich pear carved by his friend Samuel McIntire in such careful and vivid detail that it seemed real.

Boston lured Corné away from Salem and he spent his most active period there, from about 1810 to 1822. He then moved again, this time to Newport, Rhode Island, where he remained the rest of his life. His known wall paintings are in the Oak Hill Mansion in Peabody, Massachusetts, the Sullivan-Dorr House in Providence, and the East India Museum in Salem, where there is a painting signed and dated 1803.

MURALS WITH AMERICAN SCENES

Mural painting of more interest to most Americans is that depicting American scenes (Fig. 9). The best known and most prolific of our native muralists was Rufus Porter. That jack-of-all-trades became known to many through the research of Jean Lipman in *Rufus Porter, Yankee Pioneer* (1968). Porter (1792-1884) was born in Boxford, Massachusetts, attended Fryeburg Academy, married, and made Maine his home for a while. In about 1815, Porter moved his family from Portland to New Haven, Connecticut. Although he changed residences there, Connecticut remained his home until his death.

Porter murals abound with rural scenes: orchards and fenced fields, farmhouses, hills and lakes. Occasionally there were harbor scenes with ships and lighthouses. The muralist liked to paint realistic trees, sometimes covering a whole wall. The species could usually be identified by shape and foliage. Often scenes were vivid with natural colors. Occasionally, though, Porter executed whole portions of a wall, everything below the chair rail, for instance, in monochromatic shades of green, gray or umber. Of particular interest to modern decorators is Rufus Porter's own publica-

tion, *A Select Collection of Valuable and Curious Arts*, first published in 1825, containing a section in which he gives detailed instructions for "Landscape Painting on Walls of Rooms." Porter had several apprentices and many imitators. Two apt pupils were Orison Wood and Porter's nephew, Jonathan D. Poor.

John Avery was another mural painter whose work is found in New Hampshire. His murals were of the Porter type, bright and colorful, and filled with realistic, busy country scenes or ocean views.

EARLY STENCILED WALLS

The second major type of wall painting is stenciling, which has its own charm. Stenciling was the easiest and consequently the most frequently used type of wall painting (Fig. 10). It was most popular between 1810 and 1840. While some stenciling is naive, other such decoration is sophisticated, precisely planned and carefully executed, with designs placed to advantage and conforming to each other in size. The skill and sense of design among early stencilers seem to have varied greatly. The same designs or slight variations appear over widespread areas. The question arises, did the same decorators travel extensively, or did decorators, as they do today, copy each other's patterns?

VICTORIAN STENCILING

In the late 1800s, Victorian stenciling emerged with a new look, to be used in residences and churches. Two contrasting styles were in evidence. Narrow, one-piece, one-color borders were stenciled around door and window frames. In more elegant settings, elaborate patterns were stenciled on upper walls and ceilings, sometimes in color on gleaming gold leaf.

STENCILERS

The names of Moses Eaton, Sr., and Moses Eaton, Jr., are familiar to students of early wall stenciling. The senior Eaton lived first in Needham, Massachusetts, then moved to Hancock, New Hampshire, where Moses, Jr., was born in 1796. Numerous walls in Massachusetts and southern Maine attest to the skill of the senior Eaton. Moses, Jr., learned his trade from his father, practiced this art, and in time settled near his parents in Dublin, New Hampshire. Here he farmed, at least part-time. Janet Waring, in *Early American Stencils on Walls and Furniture* (1937), suggests that he left his farm long enough for a trip "west." A study of stenciled decoration west of Dublin shows that designs from stencils in Moses Eaton's kit, now at the Society for the Preservation of New England Antiquities in Boston, can be found in Athol and Deerfield, Massachusetts, Plymouth and Woodstock, Vermont, and eastern New York State near Ballston Spa and St. Johnsville.

The Eatons are the best known of the wall stencilers, but there were many, many such decorators, too many to chronicle except by areas. As an example, see *Wall Stenciling in Western New York, 1800-1840* by Philip Parr and Janice Wass, published in 1985 by the Rochester Museum and Science Center.

Chapter 2

Brush-Stroke Wall Painting: The Scroll and Border Painters

SCROLLING

In *The Complete Wagon and Carriage Painter*, Fritz Schriber gives careful instructions for painting the scrolls popular in ornamental painting, which were the hallmark of the so-called Scroll Painter.

> Scrolling is an art acquired by but a few... Scrolls...require close study, continued practice, and, more than all, an aptitude for such work, natural or inborn, and none may know whether they possess this faculty until they have tried and tried again... A blackboard will be found the best place to practice, for each line must be drawn with a *free* hand. No means for measuring, other than the eye, should be employed, and he must not be discouraged if he is forced to rub out and try again a hundred times in so simple a task as drawing a circle. This drawing of a circle is in fact the key to the whole art of scrolling, for he who can, with a free hand, draw a nearly perfect circle, will be able to perform any "sweep" with comparative ease.

SCROLL PAINTER AND HIS WORK

At first sight, broad spaces covered with brush-stroke painting appear so free-flowing that the design does not seem planned. This appearance is deceptive; the careful planning of the Scroll Painter is, in at least one case, evident upon close inspection. He used templates or a compass to plot swags and circular "frames," and a straight edge to outline borders and diamonds (Fig. 17). In the upstairs hallway of the John Turner House near Hoag's Corners, New York, the painter scribed marks in the plaster, perhaps an eighth of an inch deep, to guide his brush. Borders were defined by straight scribed lines. Curving vines, also, were marked carefully, so that the pattern for all except the finest brush strokes was composed before a brush was dipped into the paint pot. Also, exactly the same distinctive vignette appears in two houses as if painted from the same pattern: a nest with baby birds and an adult flying toward them, a worm dangling from its beak (Fig. 16).

The Scroll Painter may have learned his trade from a member of his family, or he may have been apprenticed to an ornamental painter and, like Fritz Schriber and his pupils, decorated carriages and other vehicles. One might at first guess that our artisan was still new enough at his trade to need the scribed lines he used at the Turner House and later was able to dispense with them to "draw with a free hand," as Schriber instructs. In contradiction to this theory, however, the decoration referred to is sure and swift, not the work of an amateur. This decorator probably always planned carefully and used guide lines, which were usually obliterated by his paint.

Popular Technology of Professions and Trades, Volume 2, by Edward Hazen, published in 1842, explains:

> Ornamental painting embraces the execution of friezes and other decorative parts of architecture on walls and ceilings. The ornaments are drawn in outline with black-lead pencil, and then painted and shaded, to give the proper effect.

The Scroll Painter, with his graceful sweeping vines sprouting flowers and leaves, provided himself with an identifiable hallmark. It is interesting to note that he sometimes changed the scale of his designs. Figures in the Arms House in Deerfield (Pl. 22), for example, are larger than those in other houses. When this painter was not painting all-over patterns made up of swirling vines, he often framed single motifs. Circles outlined in brush strokes are found in the French House in Conway, Massachusetts (Pl. 20), and in the Alexander House in Northfield (Pl. 19). Intersecting lines form diamond frames in the Van Wormer House (Pl. 1) and in Stratton Tavern (Fig. 18). The latter also has a scrolling border above the baseboard very much like one in the Van Alstyne home in Kinderhook (Fig. 12). At the Kittle House in Muitzeskill, New York, and the Van Alstyne House, there are flower motifs like pinwheels. In the

FIG. 1: Borders used by the Border Painter.

Turner, Van Ness and Van Wormer Houses there are friezes made of swags. In the latter two houses as well as the Kittle House, tassels are used. The walls of every home attributed to the Scroll Painter are outlined with simple brush-stroke borders (Pl. 5). In the Turner House there is a "different" architectural dado (Fig. 13). The Scroll Painter's palette was often limited to black, white and vermilion on a broad array of background colors.

BORDER PAINTER AND HIS WORK

The Border Painter clearly did not plan as precisely as the Scroll Painter (Pl. 26). Vertical stripes in a chamber of the Horton-Farrington House in Brandon, Vermont, for example, are neither equidistant nor perfectly straight. In some instances borders seem to be used only to fill space, not as an integral part of a carefully planned design.

Work has been ascribed to a single artist known as the Border Painter because painting in the Waldo, Galusha and Horton-Farrington Houses share similar characteristics. One chamber in the Galusha House has been restored using the original pattern; here there are multiple birds as there are in both chambers of the Horton-Farrington home (Pls. 25 and 26). Similar single motifs such as leaves and flowers also occur in both houses. A motif appearing in an all-over design in the Galusha House becomes a border in one of the other homes. This painter was very imaginative and liked bright colors in both design and background. Decoration is often in red, green, blue, yellow, black and white. Walls at the Galusha House are painted in a fantasy of color with bold, fanciful flowers on a pleasant gray background (Pl. 28). The Waldo home has deep blue walls. Judge Horton or Captain Farrington, first owners of the Pearl Street house in Brandon, Vermont, chose a brick red background for one second-floor chamber and a bright shade of pink for another (Pls. 25 and 26). The three houses showing the work of the Border Painter are near each other, on an old north-south route in western Vermont.

6

TECHNIQUES AND CHARACTERISTICS OF THE TWO PAINTERS

Careful examination of painted wall motifs makes it clear that the Scroll Painter worked with one color at a time over a large area. The white scrolls which become vines were done first, and then their white brush-stroke leaves were added. Vermilion strokes came next, with black accents last. The Border Painter, using more colors, may have worked with a palette and several colors in quick succession although he, too, added his black strokes last. (Paints, as discussed later, dried fast.)

Although both the Scroll Painter and the Border Painter were imaginative and innovative, their work at times shared common elements. Their designs were sometimes painted on contrasting bands of color, an effect found also on the wallpaper of the time as well as on later wall stencil borders (Fig. 10). Border designs are painted, for instance, on thin ochre or vermilion bands, perhaps six inches wide. Such decoration is found in Beach Tavern and in the Van Wormer, Galusha, and Hudson Houses.

PAINT: COMPONENTS AND PREPARATION

Artists' oil paints imported from Britain were available in American cities from the 1700s. According to an 1800 advertisement in the *Albany Centinel*, T. Pomeroy, at his store next to Lewis City Tavern on State Street, sold paints—white and red lead, Copperas, Prussian Blue, Vermilion, and Patent Yellow—along with such various other articles as "lump, loaf and brown sugar; soft shelled almonds; bottle corks, Spanish segars; rosin, rosewater; spices, and the Best Sherry Wine."

Wood and Dawson, 44 Front Street, New York City, advertised in the *Albany Register* in 1798 "Spanish Brown and yellow ochre of their own manufacture."

Wall painters, however, did not use such commercial products, but prepared their own paint, grinding dry pigment in a mortar—or later, a paint mill—and mixing it with any number of possible mediums. Skimmed milk, glue, egg, and ale were popular binders. The earth pigments raw and burnt umber, raw and burnt sienna and yellow and red ochre (or raw and burnt ochre) were readily dug from the soil as clay and washed free of impurities with water. For wall painting, the raw colors could be mixed immediately with a binder; however, when mixed with fish, nut, or flaxseed (linseed) oil, pigments were first dried. J. W. Barber wrote in *History and Antiquities of New Haven*:

> There has been discovered within three miles of this place, a prodigious quantity of a brown species of Paint. It is nearest the colour of a dark Spanish brown, and may with a little preparation answer all the purposes of a common painting...

In the Van Ness House, ornamentation in all but one room was painted directly on plastered walls without a coating of background paint. The first coat painted over the decorative frieze in the entry hall of this house clung to the brush-stroke painting it covered although all other paint on this outside wall flaked off because of excessive moisture. This suggests that the painter worked with distemper, in which pigment was mixed with glue. The mural painter Rufus Porter, in his 1825 publication, *A Select Collection of Valuable and Curious Arts*, gives instruction to wall painters:

> Dissolve half a pound of glue in a gallon of water, and with this sizing, mix whatever colors may be required for the work.

Another recipe makes use of a product every farmer possessed:

> Cheap Paint. One pound potatoes skinned and well baked. Bruise them in three or four times that weight in boiling water, pass through hair sieve. Add two pounds of white chalk powder, mixed with double its weight of water, and stir together. This mixture will form a glue to which any coloring matter may be added, even charcoal, brick dust or soot.

A third set of instructions produces "Brilliant Whitewash":

> Take half a bushel of nice unslaked lime, slack it with boiling water, cover it in the process to keep in the steam. Strain the liquid through a fine strainer, and add to it a peck of salt, previously well dissolved in hot water; three pounds of ground rice, boiled to a thin paste, and stirred in boiling hot; half a pound of powdered Spanish whiting, and a pound of clean glue, which has been previously dissolved by soaking it well, and then hanging it over a slow fire, in a small kettle within a large one filled with water. Add five gallons of hot water to the mixture, stir it well and let it stand for a few days covered from the dirt.

TRANSFERRING DESIGNS

The intricacy of some wall-painted designs and the presence of the scribed lines mentioned earlier are certain evidence that brush-stroke walls were planned, raising the question of how designs

were transferred. One method for transferring a motif from paper to a wagon, screen or wall is described in Schriber's how-to-do-it written a hundred years ago:

> ...Take a piece of tissue paper and copy the illustration, or draw a new design, then perforate the paper with a needle into small holes, thus:.....................following every outline of the design; then tie up in a thin piece of muslin some whiting to form a "pounce bag." Lay the paper pattern upon the desired spot, holding it firmly, or fasten it with tacks, and rub or pounce the whiting from the bag over it. The whiting will penetrate the holes and leave a well defined outline on the work which may be followed with the pencil [fine brush] and paint.

Ransom Cook of Saratoga Springs, New York, operated a furniture factory from 1822 until the 1840s. Much of his furniture seems to have been decorated with stenciled or oil-painted designs. His ledgers show that he, and probably his brother Nelson as well, also striped wagons, lettered post coaches, and painted floor cloths and fireboards. (Younger brother Nelson was Ransom's apprentice during the 1820s, and later traveled across the state to Buffalo, stopping for months at a time in the larger villages to paint portraits.) Among Cook designs, some of which are now at the New York State Museum in Albany, were examples of the pricked patterns Schriber describes. Patterns traced years ago in the Richard Arms house in Deerfield also show this type of pin pricking, probably intended for use in reapplying the much-worn original painting in one of the wall-painted rooms. Michel Felice Corné, one of the mural painters discussed in the preceding chapter, likewise used pin-pricked transfer drawings. Several of these have been preserved at the Redwood Library in Newport, Rhode Island.

SOME CONCLUSIONS

There were many similarities and a few differences in the work of the two wall painters discussed in this chapter. While the Scroll Painter sometimes painted directly on a plastered wall, no examples of this by the Border Painter are known. The Scroll Painter's palette for ornamentation was narrower than that of the Border Painter, but both liked variety in background colors. Similar paint and tools were used by both, and their technique for applying ornamentation appears to have been the same. Characteristic patterns distinguish and allow us to identify the work of the Scroll Painter and of the Border Painter, respectively.

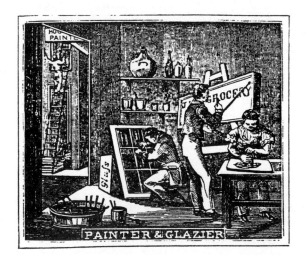

FIG. 2: Ornamental painters at work.

Chapter 3

What Kind of Craftsmen Painted Walls?

ORNAMENTAL PAINTERS

Ornamental painters were multi-talented men often willing to accept a variety of assignments in order to earn a living. Sometimes they made their home in a village and "stayed put." Occasionally they became especially adept or successful at one facet of their trade and traveled from village to village as, for example, cutters of silhouettes or wall painters. In 1828 William M. Prior advertised in the *Maine Inquirer*:

Portrait painter offers his services to the public. Those who wish for a likeness at a reasonable price are invited to call soon. Side views and profiles of children at reduced prices...

The earliest artisans in America received their training as apprentices in Europe. Old advertisements mention Gustavus Hesselius from Stockholm, Thomas Child and John Winter from London, Evert Duyckinck from the Netherlands. The European craftsmen taught native-born Americans their trades. These 18th and 19th century decorators suggested their versatility by identifying themselves variously as "ornamental and graining," "sign and ornamental," "decorative," "house and frescoe," and "house and ornamental" painters. Ransom Cook of Saratoga Springs, New York, mentioned in the previous chapter, ornamented chairs with stenciling and oil paint designs. He also painted interiors and exteriors of houses, frequently embellishing the facades of storefronts. In addition, Cook painted signs and hung wallpaper, and his ledger mentions that he "pencilled" symbols on a Masonic apron and once charged for stenciling a "coverlid."

EZRA AMES

Ezra Ames (1768-1836), who moved to Albany, New York, from Worcester, Massachusetts, in 1795, eventually became well known as a portrait artist and painter of miniatures. While learning his art and earning a reputation, he was an orna-mental painter. Ames lettered signs and oyster kegs, painted a Masonic carpet, devised a giant watch for use as a trade sign, gilded a weathervane, "drew a fancy piece on satin," painted a family coat-of-arms, and lettered banners for the Washington Benevolent Society.

RUFUS COLE

Rufus Cole of Broadalbin or Fondasbush was another New York ornamental painter. Cole grain-painted and stenciled tall clock cases and striped, stenciled, and oil-painted the square, highly ornamental sewing boxes which he signed. In the directories and census sheets of his day, Cole is recorded as "Painter, House and Sign" and as "Painter, Carriage."

JACOB EICHOLTZ

The Day-Book of Jacob Eicholtz of Lancaster, Pennsylvania, kept between 1809 and 1817, records a change of occupation from tinsmith to painter. Eicholtz, in 1809, painted two cornices and a Freemason's apron; he "lettered two plates" (probably name plates for coffins) and painted a likeness of William Pitt on a signboard for Henry Diffenbaugh's tavern in Lancaster. The ledger also indicates the sale of tin coffeepots, sucking bottles, cups, canisters and lanterns during this period. In 1812 Eicholtz listed an expenditure of $196.85 to add a "painting room" to his home, and, from that date, ledger entries show only items associated with ornamental painting and portraiture.

ITINERANT PAINTERS

The four gentlemen just mentioned became prominent because of special talents, and each acquired enough importance to have his life and accomplishments written down. Pinpointing the

identities of the itinerant ornamental painters who painted walls two hundred years ago is a difficult business. These men worked chiefly in communities where there were no newspapers to tout their skills and record their existences. Their painting was advertised mainly through word of mouth as relatives and friends visited around the countryside or tavernkeepers exhibited painting on their walls. In *Hawkers and Walkers*, Richard Wright suggests the low esteem in which such itinerants were held when he quotes a contemporary who labeled as "unprofitable laborers" all inside house painters, miniature and portrait painters, hairdressers, tavernkeepers, musicians, stage players, buffoons and exhibitors of birds and puppets.

ROUTES OF WALL PAINTERS

The wall painters with whom we are concerned worked along several early well-traveled routes. The Scroll Painter made his way along the Connecticut River, which flows south from the Connecticut Lakes in New Hampshire through communities in Vermont and western Massachusetts—Northfield, Deerfield, Sunderland, Chicopee—then south through Connecticut to the Long Island Sound. Walls painted by the Scroll Painter have also been found along an east-west route across New York State which ran close to today's Route 20 from Hoag's Corners to Geneva, then along the old Ontario and Genesee Turnpike to East Bloomfield and the Beach Tavern. The first stage line west of Albany was established by a Schenectady tavernkeeper, Moses Beal. Its first day's destination was Canajoharie, where we find the Scroll Painter's work at Dillenbeck's, a stagecoach stop. This painter left examples of his craft along a north-south route, as well, from West Fort Ann south to Muitzeskill and Kinderhook. The known route of the Border Painter is north and south through western Vermont, at least from Brandon to Shaftsbury.

SOME KNOWN WALL PAINTERS

We are aware of the names of a few wall painters. Daniel Bartling advertised his ornamental painting in Boston's *Columbian Centinel* in December, 1796, including his willingness to apply gold leaf on glass and to "ornament rooms." The advertisement of B. Bartling (Daniel's brother) and Sylvester Hall in Hartford's *Connecticut Herald* early in 1804 solicits employment painting walls "in imitation of that much admired

stamped paper." (As far as we know, this could refer to stenciling *or* brush-stroke painting.) Hall and Bartling fell into the class of "ornamental painters" since they also varnished furniture and wallpaper already hung. They decorated coaches, chaises, signs, Windsor and Fancy chairs, dressing tables, bed posts, cornices and fire screens.

SYLVESTER HALL

Hall is credited with painting the overmantel scene in the Rufus Hitchcock House in Cheshire, Connecticut, now the home of the Cheshire Historical Society and its fine museum. The painting shows the Cheshire green and the Hitchcock home, the Second Meeting House, and several "Sabba-day houses." (These were tiny one-room shelters built along the green by out-of-town residents who came to town early on the Sabbath, built fires in their cottages and placed food in the oven so that they might retreat there between church services.) There was apparently also stenciling in the Rufus Hitchcock House, a remnant of which is preserved in the museum of the New Haven Colony Historical Society.

Sylvester Hall was born in 1774 in Wallingford, Connecticut, the native village of several other known ornamental painters. Sylvester may have learned the trade as an apprentice since in 1795, when Hall was twenty-one, 25£ was subtracted from his father's estate because of Sylvester's "learning a trade." At twenty-three he married Lucy Hurlburt of Winchester. The Reverend Daniel B. Hall, in *Halls of New England*, notes that in 1803, Sylvester and Lucy with two infant daughters moved up the Connecticut River to Burke, Vermont, a small community which became their lifelong home. If this date is accurate, Hall was certainly an itinerant, since he was advertising his services in 1804 in the *Connecticut Herald*.

The following anecdotal material is from a report prepared for the first meeting of the Burke Historical Society, on February 25, 1896, by Rosalie Bowman, who commented:

> It will be fifty years tomorrow since I married into the [Hall] family and in that time Mr. Hall and wife and ten of his children have crossed the river, seven dying in the home, and I am left alone to represent the once large family.

The Sylvester Halls' first home was a log cabin on a hilltop. He was a farmer at least part-time; he was also a beekeeper, one of the first in the area. Hall swore that honey was a cure-all and suggested taking some for the toothache from which he suffered. His wife argued that the sweet salve would increase his pain. After trying his remedy, Sylvester admitted that he should have listened to

Lucy! The couple had thirteen children, and by the end of his life, Sylvester was known as a musician who led the choir in the church in Burke Hollow and acted as singing master. Mrs. Bowman wrote:

> Mr. Hall taught singing for many years. My first recollections of him are his standing at the head of the choir in the old church at Burke Hollow, with his tuning fork in hand with which he would rap on the front of the gallery and then apply to his ear and give the sound or pitch, I think it was called, from which the choir were to sing.
>
> One Sunday by some mistake the choir started on two separate tunes — before they were through the first line he rapped loudly on the front of the gallery saying, "Stop, Stop." They did stop, had the mistake rightened and went on. He was a man of strong will and seldom yielded — never until convinced of his error and then it was sometimes hard.

There is no reference in Mrs. Bowman's account to Sylvester Hall, wall painter, so there is no further clue to determine whether or not he was responsible for any of the brush-stroke painting with which we are familiar. We realize, of course, that he *could* have been the Border Painter.

INITIALS AND SIGNATURES

Names and initials have been found on walls in houses with brush-stroke painting. They are not always legible, and there is no proof that any were connected with wall painters. We must remember, too, that our ancestors were as apt as our contemporaries to write their names or initials as graffiti. Consider the number of mementoes to be found on old window panes where names, dates and quotations were often cut with the visitor's diamond solitaire. We also see initials and dates carved on old school desks, dock posts and hotel railings. It is possible, then, that names and initials discovered in wall-painted houses refer to wall painters, but it is equally possible that there is no such connection.

The Jenny Sampson House in Middleboro, Massachusetts, once had brush-stroke painting; high on a wall were initials which, in a photograph, look like "M.A.T." with the date "1803." Initials in white paint also could once be seen on a hall wall in the Arms House in Deerfield: "F S," "A H," "W B." In the front hall of the Beach House near East Bloomfield, New York, there is what might be part of a painter's signature. Graceful script in tiny letters within the pattern traces out "Bolar..." Both the Arms House and the Beach Tavern show painting characteristic of the Scroll Painter.

E. JONES AND JARED JESSUP

The Warham Williams House, once standing in Northford, Connecticut, now the northern part of Wallingford, was erected in 1750 by Parson Williams and sold after his death to the Reverend Matthew Noyes, a wealthy clergyman from Lyme. There was at least one brush-stroke-painted room here, and the names of five people who worked at the house, along with the dates their work was completed, were recorded on the inside of a closet door. The first two names were in blue paint, the last three in white:

E. Jones 1792
Jared Jessup 1809
George R. Smith 1867
This house was painted inside Jan. 26, 1889
 outside Nov. 5, 1888
by Sam Hodgetts, Wallingford, Conn.
Painted and papered by Wm. R. Brunel
 Dec. 1900

It seems logical that the wall painting was done as the Reverend Mr. Noyes refurbished his home. Assuming that the names on the door represented workmen who painted woodwork or walls within the house, it is most likely that either E. Jones or Jared Jessup was responsible for the wall painting. So far it has been impossible to find out anything about E. Jones. Esther Stevens Brazer, a prominent student of American decorative arts until her death in 1945, felt that the blue paint in Jessup's signature on the door matched the blue used in the wall painting more closely than did the blue of Jones's signature; consequently, she attributed the Warham Williams House wall to Jessup. The work of the painter identified as the Scroll Painter resembles the painting seen in a photograph of a Warham Williams House wall. Although a section of this wall exists and is owned by the New Haven Colony Historical Society, it is in storage and unavailable for study.

There are coincidences which encourage the identification of Jessup as the Scroll Painter. The Reverend Henry Jessup, in *Edward Jessup and His Descendants*, says that Jared's father, Nathaniel, moved his family from Easthampton, Long Island, to Richmond, Massachusetts, before 1800, and that six children were born there to Nathaniel and his wife, Hannah Tarbell Jessup. Jared married Lucretia Chittenden in Guilford, Connecticut, in 1802. Their daughter, Hannah, died in Richmond in 1846. Richmond, Massachusetts, is just a few miles across the state line from Kinderhook, New York, where several homes showing the brushwork of the Scroll Painter have been found. The name Jessup also occurs frequently in other areas where there was brush-stroke painting on

walls: the former Jessups' Landing, just above Hadley, New York, has been referred to in a Jessup genealogy as the place "where the Loyalist cousins lived." This is near the Jake Van Wormer House in today's West Fort Ann, New York. Joseph Jessup lived in 1800 near Ames, New York, a stone's throw from the Dillenbeck stagecoach stop near Canajoharie. In the same period, Adam Jessup was an early settler in the Northfield, Massachusetts, area, where two more wall-painted buildings, Stratton Tavern and the Alexander House, still stand. Jared's brother Edward lived after his marriage in Westfield, Massachusetts, which is near Chicopee and the Chapin House. Is all of this coincidence?

SINGLE PAINTER OR TEAM

Wall painting that can be dated accurately was completed over a short span of years, perhaps only between 1790 and 1815. It also appears that much of the known painting was done by a very small number of painters. Many of the examples shown here reveal similar characteristics and look like the work of a single individual. In other cases, two walls in a single house have painting that seems different enough to suggest the work of two men. As certain motifs or techniques become familiar, new motifs and techniques are introduced alongside them: a kind of painting used exclusively in one house is incorporated with other, previously unencountered motifs in another. The question is, did the Scroll Painter vary his style and do much of the work recorded here, or did two painters work together so consistently that the work of each took on the characteristics of the other?

OVERMANTELS AS CLUES

Overmantel painting takes on significance in this search for the identity of brush-stroke wall painters. The Border Painter's overmantels in the Galusha and Horton-Farrington Houses are quite similar. Overmantels in the Beach Tavern ballroom and the Arms House are clearly the work of the same second painter, and in each of the latter houses there is brush-stroke decoration in more than one room, some of which, at least, is the painting of the Scroll Painter. Other overmantels by this painter are known, one being in the collection of the Pocumtuck Valley Memorial Association at Deerfield.

A REFERENCE

The idea that wall painters worked in teams is substantiated by a notation in *The Diaries of Sally and Pamela Brown, 1832-1838*, edited by Blanche Bryant and Gertrude Baker (William L. Bryant Foundation, Springfield, Vermont). Since these diaries are from the 1830s, when stenciling was in its heyday, this technique rather than brush-stroke painting must be the kind referred to here:

Cavendish, Vermont
Tuesday: Two men came to paint the house in imitation of wallpaper. They mix paint with skim milk using Spanish white for white washing.
Wednesday: Mr. Livingston finished painting the house. He used rose pink to make lilac or peach blossom colors mixing it with Spanish white and milk...yellow and Prussian Blue for green. They had between six and seven dollars for the job.

FIG. 3: Initialed and dated wall.

Chapter 4

Brush-Stroke Painting on Tinware, Country Furniture, Stoneware and Vehicles

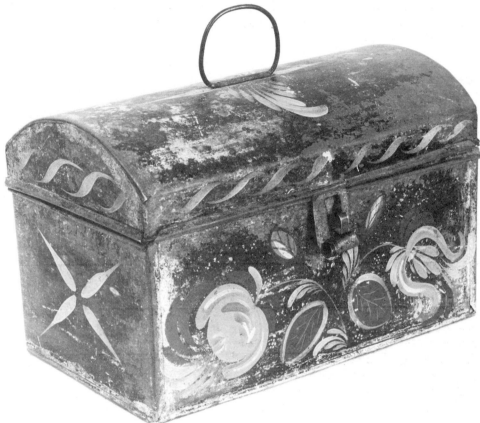

FIG. 4: Tin trunk used for legal papers. Notice brush-stroke tulip. Ex-collection of the author.

BRUSH STROKING

The type of painting on walls referred to in this volume as "brush-stroke" painting has been used for centuries on ornamental and utilitarian objects. The painter had merely to learn the skill of pressing down on his brush to make the wide part of the stroke, then, lessening the pressure, lifting the brush to leave a fine, usually curved "tail" of paint. In this country the method was commonly used by the professionals who decorated tinware 160 years ago and is still used by those who are practicing the art today. It has also been popular among painters of china and slip-decorated pottery and of American country furniture. Motifs used by the wall painters can also be found on late 18th and 19th century gravestone sculpture and on textiles, such as appliquéd quilts.

TINWARE

The painting of the tinware "flowerers" strongly resembles the work of the Scroll Painter. This wall decorator appears to have started his painting in the 1790s, which antedates brush-stroke decoration on American tinware, or "country tin," as it is now familiarly called. Tinware was probably not being painted much earlier than the eighteen-teens; a Connecticut contract outlines an agreement between Oliver Filley, master tinsmith of Simsbury, and Joseph Brown, which committed Filley to employ Brown beginning in January, 1811, teaching him the arts and mysteries of "Japanning, flowering and painting Tinware..."

Motifs on tinware were apt to be floral with birds sometimes incorporated in the designs. A single motif from the wall of the Van Wormer kitchen (Pl.

13

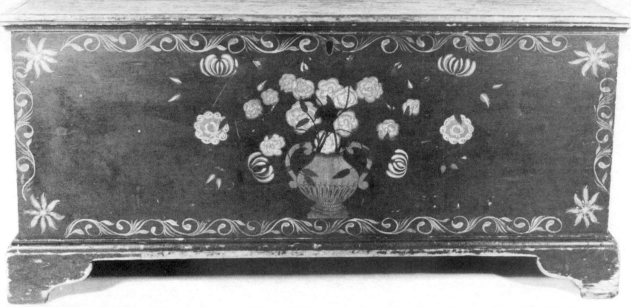

FIG. 5: Six-board chest from Schoharie, New York. Painting includes brush strokes and scrolls. Photo courtesy *Maine Antiques Digest*.

1) was a suitable design for a coffin-lid tray or a tin trunk (Fig. 4). The geometric, star-like motif also repeated in the Van Wormer pattern resembles brush-stroke motifs painted by Ann and Minerva Butler in their father's tinsmithing and decorating shop near Greenville, New York. Small-scale versions of borders around the door frames in the back parlor of the Van Ness House could be used to excellent effect around lines of construction of a tin tea caddy or trunk.

The swag-and-tassel used on walls and copied directly (it would seem) from wallpaper designs was also used on tin trunks. A swag on tin might be solid color or made to appear three-dimensional by the addition of thin alizarin and white overstrokes. Clusters of brush strokes between swags represented tassels. The swags of the wall painters were more elaborate, often composed of garlands of foliage with tassels which were more realistic than those on tinware.

BRUSH-STROKE-DECORATED FURNITURE

The ornamenters of country chairs employed motifs and techniques very similar to those used by decorators of tinware. Some small trunks and six-board chests are painted in the same manner. The six-board chest illustrated (Fig. 5), from the Schoharie, New York, area, shows the skilled hand of a brush-stroke painter. A York County, Pennsylvania, "kischt" or dower chest in the Boston Museum of Fine Arts exhibits a border like one in the Judge Horton-Farrington House in Brandon, Vermont, which was painted by the Border Painter. Taunton chests are covered with white vines, a favorite motif of the Scroll Painter, marvelous examples of which are found in the Turner and Van Ness Houses (Pls. 14, 6).

Furniture as well as tinware was frequently striped, often with a single line. On walls, such a definition or separation of designs was often accomplished by a change of background color, as exemplified by the vermilion and gray backgrounds behind borders in the Van Wormer House. The Van Ness House, however, has striping in the entry hall to separate borders along lines of construction from the undecorated areas and to help define the frieze. Here the stripes themselves are decorated with dots (Pl. 5).

Decoration by German-Americans in eastern Pennsylvania, somewhat like that on brides' boxes brought from Europe, has similarities with brush-stroke wall painting. Work attributed to one Heinrich Bucher from Berks County, active during the early 1800s, is a fine example of this. Similarities are in motifs, colors, and a particular technique used.

Like the Scroll Painter, Bucher painted tulips, along with other flowers less easy to identify. Colors used were bright: the reds, blues, greens and golds used by both the Border Painter and the Scroll Painter when at their gayest. One of the most obvious likenesses between the work of the Scroll Painter and that of Heinrich Bucher is a special technique which each used at least part of the time: the complete design was first painted boldly in white, then colors were applied, probably one at a time for a whole box, or room, allowing some of the white to show around edges or through brush strokes when the brush was lightly loaded.

FIG. 6: Motif from kind of chest painted in Taunton, Massachusetts, during the second quarter of the 18th century resembles work of the Scroll Painter.

FIG. 7: Motifs popular with both stoneware decorators and wall painters.

This technique was used on Beach Tavern walls. The first coat of white allowed marvelous contrast as a background for the brilliant colors which the painters favored. Both Bucher and the Scroll Painter often used dark backgrounds. The darker greens and blues used in design motifs contrast much more effectively against white than against the black paint Bucher preferred using on boxes and the brick red background favored by the Scroll Painter.

MOTIFS ON STONEWARE

In stoneware ornamentation accomplished with slip, we again see the use of motifs prevalent in wall paintings. Although Thomas Commeraw of New York City was using swags and tassels in the late 1700s, almost all of the American stoneware decoration was executed later than the wall painting. Stoneware painters were fond of birds, and, like the wall painters, of flowers and foliage. One three-gallon jug from M. Tyler and Co. of Troy, New York, has a floral motif which might have come directly from a piece of tinware or from the type of wall design which framed individual sprays of flowers with diamonds. Bunches of grapes like those in the frieze in the Van Ness House (Pl. 3) and tulips also grace stoneware.

DECORATION ON VEHICLES

Wagon, carriage, sleigh and stagecoach painters, too, made use of some of the patterns used by wall painters. Scrolls, especially, were popular among these artisans. Scrolling motifs, along with directions for scrolling like those quoted in Chapter 2, were published for coach painters to follow.

GRAVESTONE DECORATION

Decorative scrolls, meandering vines, swags and urns with flowers reminiscent of overmantel paintings were all incorporated in the designs used by gravestone cutters, as well. Scrolls and swags and swirling vines became part of the overall pattern, while an urn with flowers was apt to be the central motif on a grave marker. Some examples of the latter are very much like the overmantel paintings in the Galusha and Horton-Farrington Houses.

Brush-stroke wall painting was apparently done during a very limited period of time. The fact that wallpaper became easier to acquire and less expensive in the 19th century must have reduced the demand for wall painting. What happened to the wall painters? It is possible that they occupied their time and earned their livings at one of the associated kinds of ornamentation in vogue during the early 19th century; perhaps they painted in the shops that ornamented stage and mail coaches throughout the 1800s. It is also possible, on the other hand, that very few ornamental painters ever practiced brush-stroke wall painting.

FIG. 8: Wooden block print. Photo courtesy Shelburne Museum.

18

Chapter 5

Brush-Stroke Painting and Wallpaper

IMPORTED WALLPAPERS

Throughout the 1700s the homes of affluent Americans were decorated with wallpaper, obtainable directly from the importers or, in some cases, from stationers and booksellers. Before the Revolutionary War, English wallpapers dominated the American market. This industry did not flower, however, in this country until the late 1700s, when American papers with comparatively simple designs became available in greater quantities. By 1800, thirty or more entrepreneurs had begun wallpaper manufacture in America. French papers were brought into this country when British trade restrictions ended, and for the first three-quarters of the 19th century, the French monopolized the American market. Due to technological advances, the French imports were of high quality and especially appealing. Until the late 19th century, American wallpaper manufacturers had difficulty competing with French and English paper makers. Notice that as early as July 30, 1799, the *Albany Register* carried this advertisement for Thomas Russell, at the Sign of Raphael's Head, 20 Market Street, in New York City: "An elegant assortment of American, English, and French Paper-Hangings with festoon and other borders."

TECHNIQUES OF MANUFACTURE

Early wallpapers were printed on "laid" stock, formed in a mold on a screen, perhaps two-by-three feet in size. The pieces of paper were glued together, and background color applied by painters using wide brushes. When the paint dried, it was overprinted by hand with wood blocks, one for each color. It was not until the 1830s that continuous roll paper was commonly used in the United States and printed with rollers rather than individual wood blocks. The use of wood blocks remained popular, however, until mid-century.

PAINTING IMITATES WALLPAPER

Painted wall designs were, as B. Bartling and Sylvester Hall suggested in their 1804 advertisement, "in imitation of wallpaper." Many French motifs were inspired by the patterns of pioneer wallpaper designer Jean-Baptiste Reveillon. Floral patterns, hunting scenes, and, of especial interest to us, motifs taken from Pompeian wall paintings were among patterns from French designers. Geometric configurations appeared along with severe classical figures and forms. Exotic, mural-like panoramas chosen from varying times and places also graced French papers. In the United States, Ebenezer Clough marked the death of Washington in 1799 with a wallpaper showing the figures of Columbia and Justice at Washington's grave monument with its exaggerated urn and an eagle perched on its finial.

ENGLISH AND AMERICAN BLOCK PRINTS

Of greatest relevance, though, to a study of the effect of wallpaper patterns on American brush-stroke wall painting are the English and American block prints, which featured either small repeated motifs or relatively simple borders. Several popular English designs, such as sweeping, scroll-like vines with leaves and flowers, are repeated on American brush-stroke-painted walls. Wallpaper designers used scrolls also in formal borders. Nosegays framed within a diamond grid on an 18th century English paper were much like those used in Jacob Van Wormer's cottage. Motifs in both wall painting and wallpaper often appear framed, within a circle, an oval, or a diamond (Pl. 19). Bird motifs were favorites: peering from foliage in the wallpapers, pecking at painted grapes, or flying across the painted wall of a Ver-

mont or New York State bedchamber. Architectural elements such as columns, arches, urns, and balusters are found on 18th and 19th century wallpaper. Once in a while these occur in freehand wall painting beneath the chair rail (Pl. 16 and Fig. 13). At the turn of the 19th century, urns and panoramic scenes were used above the mantel in a painted room or as panels in a papered room. Borders, in their broadest sense, were of major importance in wall treatments. At the top of a wall, a border became a frieze; at chair rail height, a dado. Painted borders and wallpaper borders were used in exactly the same manner: they followed lines of construction, around door and window frames or mantels, for example. When architectural details were elaborate, around a fireplace or at the top of a door frame, wallpaper borders were cut and matched carefully to outline the fancy detail. The wall painter painted around these details, emphasizing them. Borders were sometimes used in this way even when patterns were also used to cover broad wall expanses. Perhaps more effective was the custom of painting the wall or wallpaper first with a solid color, then using only extravagant borders. Old newspapers ran advertisements for "common" or "elegant" borders:

> Paper-Hangings suitable for lower rooms, chambers and halls with elegant festoons and common borders, from 1-10 inches in breadth. Rolls are 12 yards in length. From 2 shillings, 6 pence to 20 shillings per roll.

> Spencer and Webb: Paper Hanging Manufactory, Mark Lane, Albany.

Swags, or "festoons," as they were identified in advertisements, used as friezes were present on both types of wall treatment. Borders in both painting and wallpaper abounded with tassels and bowknots which hung between the swags.

COLORS USED

There is an obvious similarity in the palettes favored by the designers of wallpapers and wall paintings. Backgrounds were often tan, gray, blue-green or ochre. (The older plaster, sometimes left as unpainted background, was the color of light brown sand.) Grisaille, monochromatic painting in shades of gray, was commonly used by the paper manufacturers. Wall painters were usually less subtle although they frequently used black and white designs accented only by an occasional dash of vermilion.

WALLPAPER VERSUS WALL PAINTING

This may be the proper place to address a question often asked: was wall painting done because the homeowner preferred it or because it was less expensive than wallpapering? The query is not an easy one to answer. It was probably cheaper to hire a wall painter, assuming one was readily available, than to purchase wallpaper and then hire an experienced paper-hanger to glue it to the walls. When many of the homes with brush-stroke painting were built, they were among the most elaborate in their communities, the homes of well-to-do gentlemen who could, if they wished, have afforded the cost of wallpaper. Perhaps, especially in remote areas, wallpaper was too difficult to obtain and apply. There are, however, some houses where wall painting and wallpaper appear to have lived side by side, both applied when the home was new.

A study of the rooms within individual houses where wall painting was originally used might tell us something—if it were possible to make an accurate list. It would be wrong to assume that the rooms where traces of painting have been found were the only rooms in these homes where this painting once existed. In the houses discussed in this volume, painting was found in fifteen first-floor rooms, some of these parlors or gathering rooms in taverns. In several of the more elaborate residences, though, no trace of wall painting has been found in the rooms where visitors would normally gather. This reinforces the idea that wallpaper, when available, was used for the rooms in which owners entertained in the more formal houses, such as the Van Ness House, the French House and the Galusha Homestead. At any rate, by the early 1800s William Poyntell of Philadelphia was advertising his wallpaper with flocked and plain patterns "cheaper than whitewashing," and we are left to form our own conjectures about factors affecting the choice of wallpaper or wall painting at the turn of the 19th century.

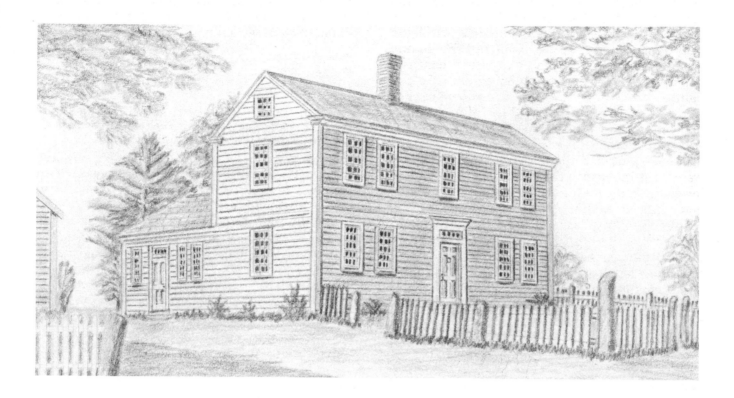

ABBOTT-BREWSTER HOUSE—Ossipee, New Hampshire, circa 1805
An Example of a Mural-Painted Wall

These charming Porter-type walls are in the spacious center-chimney home of Marjorie B. Clarke in Ossipee, New Hampshire. Mrs. Clarke believes that her home was built between 1804 and 1809, since in 1809 Daniel Abbott sold the property to John Brewster "with buildings thereon." The two-story main part of the house, in which the painted walls are found, has center halls upstairs and down with a single room on each side. There is a one-story ell with an attic on the back of the house. Front windows are nine-over-six and may be sheathed on the inside with wooden "Indian" shutters made to slide into the wall.

The murals are along the walls of the front entrance hall and in a large upstairs chamber. They have never been papered over and remain bright, the background plaster white and fresh. Throughout the bedchamber the murals are above the chair rail only. The painting is in natural colors: the tree trunks are gray, the foliage in shades of green and yellow, the fields in harvest colors. In this room the woodwork is gray and the floors are pumpkin. Mrs. Clarke, a painter herself, has tried to identify the mural painter. She suggests that there are some characteristics of early Porter walls. Since Ossipee is near Wolfsboro, the home of mural painter John Avery, Mrs. Clarke studied her walls, searching for Avery's hallmarks, but did not find them. It is possible that a team of painters was responsible for the painting. Mrs. Clarke says:

I would like to think that the young Porter and Moses Eaton, traveling together, arrived in the Ossipee area and decorated a number of houses including the one in which I live.

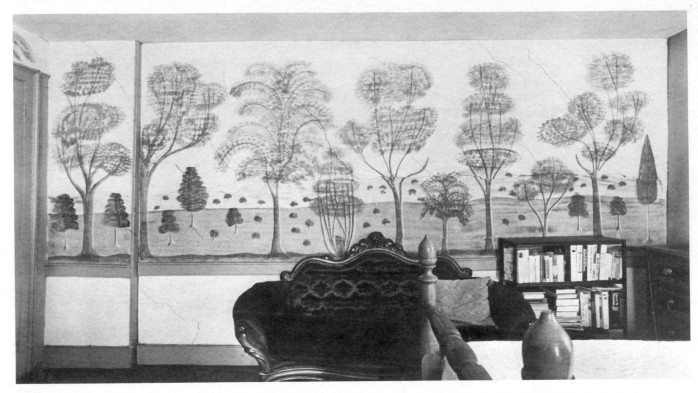

FIG. 9: Mural in Abbott-Brewster House, upper chamber. Photo courtesy Historical Society of Early American Decoration, Inc.

FIG. 10: Stenciled wall in upper chamber, J. Hopkins House.

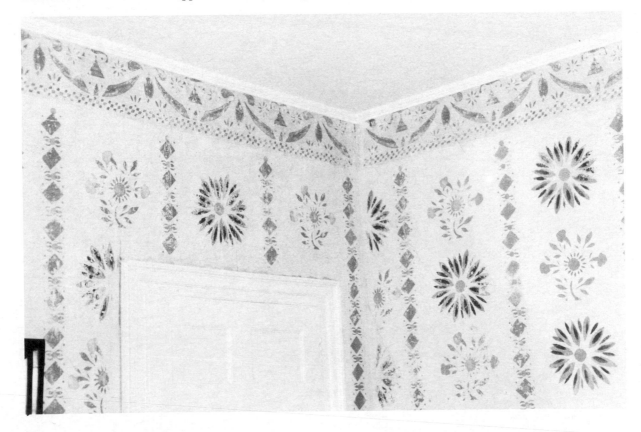

J. HOPKINS HOUSE—Granville, New York, 1819
An Example of a Stenciled Wall

An imposing early 19th century home sits on the corner of Parker Hill Road and Route 22 about three miles south of Granville in eastern Washington County, New York. The red brick house is of generous size and rests on a knoll amid tall shade trees. The home was built in 1819 by J. Hopkins and remained in the Hopkins family until mid-century, when it was purchased by the Breimer family.

The house has a center hall with spacious rooms on each side. An upstairs chamber and the upper hall have bright original red, green and black stenciling on their walls. The ornamentation is that of a stenciler who did considerable work in eastern New York, at least along the state border. He often used a contrasting band of color beneath a border at the top of a wall. In the Hopkins House, the background color of friezes in both the hall and chamber is a medium shade of blue. The rest of both walls is pale yellow. Vestiges of similar stenciling were found in an abandoned house on Crawford property near Argyle, New York. Three elements, the frieze from the Hopkins House hall,

the running border over the baseboard in the bedroom, and a smaller round motif also used in that room, seem exactly like decoration used in the Argyle house. The large black-on-green figure with the red center was also found on a piece of plaster salvaged from a house in Stephentown, south of the Hopkins House but along the same north-south route, and saved in the collection of Donald Carpentier of Eastfield Village. The border used over the chair rail in the chamber is like one which still exists over a chair rail in a hall in the early farm home of Mrs. Robert Cromie, who lives just west of Ballston Spa, New York. Ballston Spa is in Saratoga County, which borders Washington County.

The old Hopkins House has been restored by its present owners, the Mannuccis, and additional rooms have been stenciled appropriately by Nancy Mannucci. There is still original decoration to be uncovered, beneath wallpaper in the lower hall. Recently shadows of a formal leaf border have been discovered beneath paint on the stairs and risers in the front hallway.

23

Houses with Brush-Stroke-Painted Walls

Building	Location	Date of Construction	Probable Owner When Painting Done	Present Owners	Use	Rooms Where Painting has Been Found	Building Standing?	Painting Exposed Now?	Painter	Figures or Plates
1 Van Wormer House	West Fort Ann, N.Y.	c. 1790	Jacob Van Wormer	NYS Museum (piece of wall)	Residence	Parlor; other first-floor room	No	Not exhibited	Scroll	Pls. 1 & 2; Fig. 11
2 Van Ness House	Kinderhook, N.Y.	1797	Peter Van Ness	National Park Service	Residence	Entry hall; upper hall; back parlor; upper bedchamber	Yes	No	Scroll	Pls. 3, 4, 5 & 6
3 Van Alstyne House	Kinderhook, N.Y.	c. 1760	Peter Van Alstyne	Iris and Harold Roth	Residence	Entry hall	Yes	Section in cellarway	Scroll	Pl. 7; Fig. 12
4 Van Alen House	DeFreestville, N.Y.	1794	Evert Van Alen	Sam Swanson	Residence	Upper bedchamber	Yes	Yes	Unknown	Pl. 8
5 Schermerhorn-Pruyn House	Kinderhook, N.Y.	1713 1760s c. 1790	Arent Pruyn	Dr. and Mrs. Roderic Blackburn	Residence	Dining room (1790 addition)	Yes	Not original; replicated	Scroll	Pl. 9
6 Kittle House	Muitzeskill, N.Y.	c. 1760	Johannes Kittle	—	Residence	Parlor	Yes	Unknown	Scroll	Pl. 10
7 Hudson House	near Malden Bridge, N.Y.	c. 1790	Samuel Hudson	Mr. and Mrs. Richard Dorsey	Residence	Parlor	Yes	Yes	Scroll	Pl. 11; Fig. 19
8 Douglas-Gardner House	Stephentown, N.Y.	1766	William Douglas	Patricia S. Stewart and Jeanne Muncey	Residence, school	Halls; stairway	Yes	Yes	Scroll	Pl. 12
9 Turner House	near Hoag's Corners, N.Y.	c. 1790	John Turner	Rosemary and William Zullo	Residence, church?	Upper hall; parlor	Yes	Yes	Scroll	Pls. 13 & 14; Fig. 13
10 Dillenbeck House	near Canajoharie, N.Y.	c. 1806	John J. Dillenbeck	Mr. and Mrs. John Woods	Tavern & residence	Large first-floor room	Yes	No	Scroll	Pl. 23
11 Beach Tavern	East Bloomfield, N.Y.	c. 1800	Ashbel Beach	Gene and Mary Burlingham	Tavern & residence	Entry hall; upper hall; parlor; ballroom	Yes	Yes	Scroll & perhaps partner	Pls. 15, 16, 17 & 18; Fig. 15

No. & House	Location	Date	Builder	Current Owner	Use	Room			Type	Reference
12 French House	Conway, Mass.	c. 1760	Thomas French	—	Tavern & residence	Upper bedchamber; hallway	Yes	Yes	Scroll	Pl. 20; Figs. 16 & 19
13 Stratton Tavern	near Northfield, Mass.	c. 1762	Hezekiah Stratton, Jr.	Old Sturbridge Village, Inc.	Tavern & residence	Upper bedchamber	Yes	Yes	Scroll	Figs. 17 & 18
14 Alexander House	near Northfield, Mass.	c. 1774	Simeon Alexander	Alice and John Kiablick	Residence	Parlor	Yes	Yes	Scroll	Pl. 19; Figs. 16 & 19
15 Arms House	Deerfield, Mass.	c. 1750	Samuel Childs or Christopher Arms	Joan and Richard Arms	Residence	2 front rooms	Yes	Yes	Scroll	Pls. 21 & 22
16 "Landlord" Williams House	Sunderland, Mass.	c. 1720	"Landlord" Oliver Williams	SPNEA (piece of wall)	Tavern & residence	Upper bedchamber	No	Section at H. G. Otis House, Boston, MA	Scroll	Fig. 20
17 "Landlord Abel" Chapin House	originally: Chicopee, Mass.	c. 1725	Major Moses Chapin	Barbara and Peter Goodman	Tavern & residence	Taproom	Yes; in Mill River, Mass.	Yes	Scroll	Pl. 24
18 Wilcox House	Westfield, Conn.	Unknown	Unknown	New Haven Colony Historical Society (piece of wall)	Residence	Unknown	No	At request	Scroll	Fig. 21
19 Horton-Farrington House	Brandon, Vermont	1799	Hiram Horton or Daniel Farrington	Nancy and Charles Jakiela	Residence	2 upper bedchambers; entry hall	Yes	Yes	Border	Pls. 25 & 26; Fig. 22
20 Waldo House	South Shaftsbury, Vermont	c. 1770	Captain Abiathar Waldo	Mr. and Mrs. David Newell	Residence	Parlor	Yes	Unknown	Border	Pl. 27
21 Galusha House	South Shaftsbury, Vermont	1783 1809	Gov. Jonas Galusha	Marjorie Galusha	Tavern & residence	2 bedchambers	Yes	Yes	Border	Pl. 28
22 Bame House	Kinderhook, N.Y.	1816	William and Anna Bame	William and Sharon Palmer	Stagecoach stop	Remnant beneath house	Yes	No	Unknown	

VAN WORMER HOUSE—West Fort Ann, New York, circa 1790

Jacob Van Wormer has left a mark on the upstate community he called home, a hamlet once known as Van Wormer's Village and now familiar as West Fort Ann. A bay in nearby Lake George is still called Van Wormer's. Described as "a stalwart, symmetric man of giant proportions," Jake moved to the lower Adirondacks from Old Schaghticoke across from Stillwater, New York, a settlement made up of Dutch families who had traveled north from Albany. Van Wormer married Polly (Marytje) Oller and was a member of the Third Company of the Hoosick and Schaghticoke Militia and Captain DeGarmo's Company in the 14th Albany County Regiment, becoming a second lieutenant in March, 1780. Some time after the Revolutionary War and before 1790, the veteran moved his expanding family (eventually he and Polly had four sons and four daughters) to Podunk Creek, about halfway between Westfield, now Fort Ann, and eastern Lake George. The Van Wormers were pioneer settlers in this area and Jake built and operated the first sawmill there. In 1795 Jacob was classified among "electors not possessed of freeholds, renting tenements of the yearly value of forty shillings and qualified to vote for assemblymen."

The pioneer earned his reputation as an aggressive fighting man during combat and showed his feelings of guilt when, after the war, he became a church member and was obliged to confess his sins. At the time of the Revolution, the Continental Congress required militiamen to furnish "a cutting sword or tomahawk, a musket, bayonet, cartridge box and twenty-three rounds, twelve flints and knapsack." Van Wormer made a long-handled tomahawk to carry and, in his confession upon joining the church, recounted his use of the weapon. The original account, written in dialect, has been anglicized for clarity.

I struck to the right, and I struck to the left, and I killed my enemies and that was all right. But one poor fellow threw down his arms and cried for quarter but I was so mad with the fighting I killed him, and that was murder. And when Burgoyne with his army crossed the river at Fort Miller, I shot a Britisher who was swimming in the river, and that was murder, and that was all I murdered. The rest were killed in fair fight.

Jake and Polly Van Wormer left evidence of the Scroll Painter's work in their Cape Cod-style home. Discovered during a survey of old residences in 1976, the bicentennial year, this painting on the walls of two major rooms on the main floor of the cottage led finally to the research which is recorded in this volume.

An 1807 assessment roll shows that the Van Wormer property was valued at $900, an amount large enough to suggest that the story-and-a-half house had been built by then. The house has now been razed, but a section of painted wall from one of the rooms has been saved and is owned by the New York State Museum in Albany.

In the parlor, painting was done against a vivid shade of blue-green (Pl. 2). As was often the practice of wall stencilers, also, there are borders of contrasting color over the chair rail, around door frames and windows. The seven-and-a-half-inch border in the parlor was gray, the color used as well in the kitchen frieze. On the gray band there were tulip blossoms of white, blue and vermilion with a simple line of black dots and white brush strokes flanked by smaller vermilion ones at the edge of the band. On the main part of the wall, above the chair rail, were graceful white scrolling vines with flowers and foliage of black, white and vermilion brush strokes.

A room at the back of the house was also painted in gay designs with vivid color. This room must have served at one time as the kitchen (Pl. 1). Here the pattern was above the chair rail. The background color is now difficult to determine, but was probably an off-white. The contrasting band of deep pink which bordered lines of construction has worn very thin. Brush strokes on this band were black and white. At the cornice level the gray swags were perfectly even, outlined by a simple brush-stroke edging with fat tassels of black, white and vermilion hanging on ribbons. The broad area to be decorated was divided into diamonds which are almost squares on point, delineated by pairs of alternating black and white strokes. Each diamond featured a different motif although the pattern was repetitive with tulips, a geometric motif, a spray of foliage, at regular intervals.

Painting in this home is an example of the Scroll Painter's finest work. Color choices are exquisite. Designs are very carefully thought out; in the back room there were carefully planned repeat motifs. There was an extraordinary amount of fine detail in this house: details and accents were plentiful both on major motifs and in borders.

FIG. 11: Motif from Van Wormer kitchen wall.

VAN NESS HOUSE—Kinderhook, New York, 1797

According to local tradition, Martin Van Buren's grandfather purchased from the Indians the estate we now know as the Martin Van Buren National Historic Site. Subsequently the land was acquired by Judge Peter Van Ness, a well-to-do Kinderhook lawyer, whose son William was a close friend of Martin Van Buren. In 1801 the future President left Kinderhook and his job as a law clerk in the office of Francis Sylvester to join William Van Ness in New York City and continue his study of law. After receiving his license to practice, Van Buren returned to his native area.

Judge Peter Van Ness moved into his newly-built Federalist mansion, which he called Kleinrood, in 1797. The judge died in 1804, and William came into possession of the house, which attained some notoriety when he acted as second for Aaron Burr in the duel which killed Alexander Hamilton; it was rumored that William harbored his friend at the estate. This "bad publicity" may be balanced by the belief that Washington Irving wrote his *Legend of Sleepy Hollow* while at the Van Ness home serving as tutor to the Van Ness children.

When in 1839 President Van Buren chose a home in which to retire, he purchased the house Peter Van Ness had built. Van Buren enjoyed his country home, entertained political acquaintances frequently, and visited Saratoga Springs dur-

ing the summer season. At Lindenwald, the name he gave to the estate, he rode horseback happily all year round, in wintertime covering his balding head with a fur driving glove. Local horsemen frequently gathered for lively competition at the Van Buren estate.

Soon after the President's retirement, Van Buren's son Smith moved his family into the large residence with permission to make suitable changes to the mansion. The prominent architect Richard Upjohn was employed to design additions to the house: a porch, dormers, a Victorian gable on the front, a four-story brick tower on the back. The ex-President commented on changes to the structure, saying:

> What curious creatures we are. Old Mr. Van Ness built as fine a house here as any reasonable man could...its taste of what was then...deemed the best... Wm. P. came and disfigured everything his father had done. I succeeded him and pulled down everything without a single exception— every erection he had made with evident advantage. Now comes Smith and pulls down many things I had put up and makes alterations without stint... What nonsense.

The estate subsequently went through a number of owners before it was purchased in 1974 by the National Park Service to be restored to the time of

Van Buren, whose presidency made the mansion a historic site of national interest.

When wallpaper was removed in the process of restoration, designs could be deciphered through a thin coat of blue paint on the front hall walls. Because it was usual for more than one room in a house to be decorated by a wall painter, a search was made throughout the mansion by raking a spotlight across the walls. The decorator's thick paint cast discernible shadow outlines identifying wall painting in three additional rooms.

The first decoration on the walls of the four rooms was brush-stroke painting done by the same hand as the painting in the Jacob Van Wormer House. This painting, except in the case of one upstairs chamber, had been applied directly on plaster without a base coat of paint. Designs were found in the front hall (Pls. 3 & 5), a back parlor (Pl. 6), the second-floor hallway (which may have been used as a bedchamber) (Pl. 4, shown vertically), and in a second chamber (the one eventually chosen by Van Buren as his own). In the latter room a coat of moss green paint was applied to the wall before the painter added his embellishments. By the 1970s partitions had been changed and all of the walls had been either papered or painted over, or both. Only because of the heavy paint was it possible to see designs and subsequently to trace them by doing wall rubbings in the same way one would rub a gravestone to duplicate its sculpture and inscriptions. Careful sanding through the paint determined colors. The effort was rewarding since different charming designs were discovered in each of the four rooms.

Appropriately, the front hall wall with its high ceilings was decorated with an imaginative frieze of carefully measured swags, each with similar elements arranged slightly differently, and clusters of sienna-colored grapes which hung temptingly between the swags. Leaves were deep green and flowers were white or pink, the vermilion varied by the addition of white and umber. Around door and window frames, over baseboards, and over and under a chair rail, there were borders.

Above the chair rail, borders were made up of alternating leaves and brush strokes; below the rail, black and white brush strokes alone formed a border. These designs must have contrasted dramatically with the early buff-colored plaster. Probably in the course of Smith Van Buren's structural changes, the back wall of the hallway was removed, enlarging the area to make a ballroom.

In a back parlor, design was again concentrated above the chair rail. This time there was an all-over pattern made up of sprigs of brush-stroke foliage somewhat like the pattern in the Van Wormer parlor but without scrolling vines to connect the sprigs. A brush-stroke border in three colors followed the lines of construction. The palette here was the Scroll Painter's seeming favorite: black, white and vermilion.

In the room at the top of the present stairs, one decorative element was repeated—the crisp, contrasting borders used above and below the chair rail in the front hall. A completely different frieze was added, reminiscent of borders on country tinware and unlike borders found in other houses, a running vine with foliage, flowers and buds, elegant and varying all around the room. Here the frieze could be rubbed easily; it was accessible from a high scaffolding the plasterers had constructed in order to restore the ceilings.

Adjoining this room is the chamber where the walls were painted green before decoration. Several coats of paint had been applied over the original painting and it was difficult to identify designs; on one wall, only a single tassel could be discerned. The frieze was composed of swags consisting of clusters of white leaves with black veins and vermilion accents. Black tassels dangled between swags. No borders could be discovered around door and window frames although they probably existed originally.

Although the wall paintings have been recorded on paper, most traces of the earlier painting have been covered, since the historic site is being restored to the mid-19th century when Van Buren lived there.

VAN ALSTYNE HOUSE—Kinderhook, New York, circa 1760

The gambrel-roof house was popular in this region from 1760 to 1785. This one probably dates from the 1760s, since the owner of the house at the time of the Revolutionary War was Peter Van Alstyne (1748-1811), and the property had been in his family for some time. Peter, married to Alida Van Alen, also of Kinderhook, was a Loyalist who was forced to leave his home in 1777, going to Kingston in Ontario, Canada, where Alida eventually joined him. The house was confiscated by Kinderhook Patriots, and, in time, Peter asked for reparations for his home plus six hundred acres of land. Later a Van Alstyne relative purchased the house.

Today the Scroll Painter's designs show only on the plaster wall of a cellarway (Pl. 7) which was at one time part of the front entrance hall. The decoration goes from baseboard to ceiling, and was applied directly on the plaster without a base coat of paint, the same situation as that in the nearby Van Ness House. Here it is possible to see what can merely be guessed at in the Van Ness home, since in the latter house every decorated wall has been painted over. Motifs in the Van Alstyne House are the same kind of random brush-stroke designs found in the back parlor of Lindenwald. Fragments of a border over the baseboard are

much like a design in the Stratton Tavern (Fig. 12). The artist's palette is limited to black and white with a few accents of vermilion.

FIG. 12: Painting over baseboard in Van Alstyne House resembles that in Stratton Tavern.

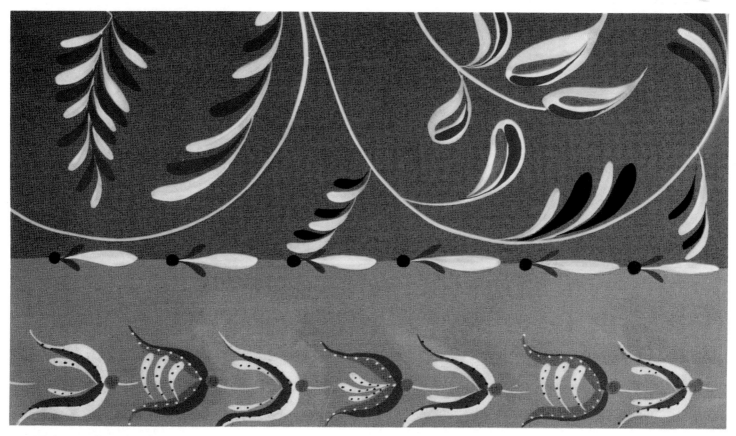

PLATE 1: Van Wormer House
Kitchen.
Courtesy Mr. and Mrs. Benjamin Campney and the New York State Museum.

PLATE 2: Van Wormer House
Parlor.
Courtesy Mr. and Mrs. Benjamin Campney.

31

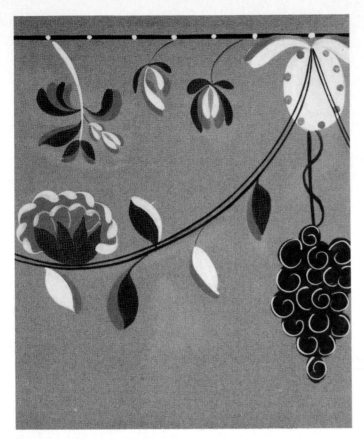

PLATE 3: Van Ness House
Entry hall. Frieze.
Courtesy Martin Van Buren National Historic Site.

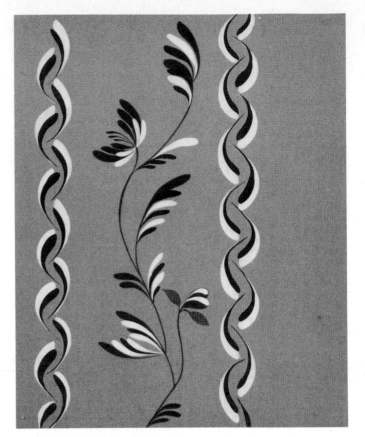

PLATE 4: Van Ness House
Upstairs hallway. Frieze.
Courtesy Martin Van Buren National Historic Site.

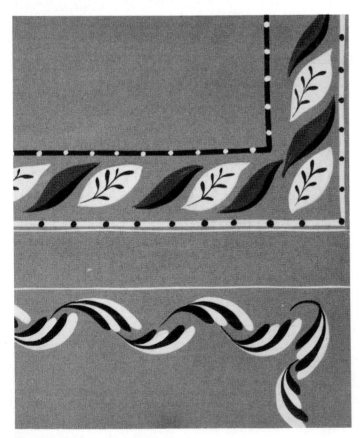

PLATE 5: Van Ness House
Entry Hall. Borders above and below chair rail.
Courtesy Martin Van Buren National Historic Site.

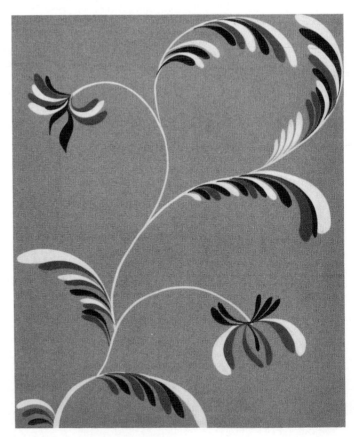

PLATE 6: Van Ness House
Study. Above chair rail.
Courtesy Martin Van Buren National Historic Site.

PLATE 7: Van Alstyne House
Originally in hallway.
Courtesy Mr. and Mrs. Harold Roth.

PLATE 8: Van Alen House
Upstairs chamber.
Courtesy Sam Swanson.

PLATE 9: Schermerhorn-Pruyn House
Dining Room. On chimney-breast.
Courtesy Dr. and Mrs. Roderic Blackburn.

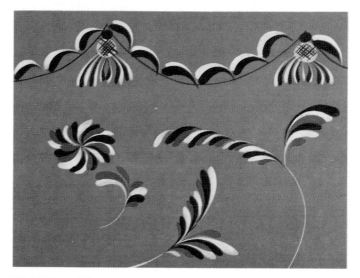

PLATE 10: Kittle House
Parlor.

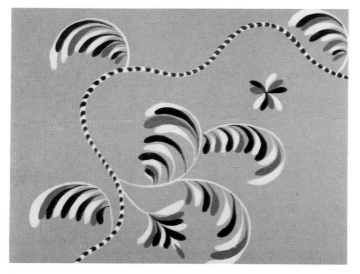

PLATE 11: Hudson House
Parlor.
Courtesy Mr. and Mrs. Richard Dorsey.

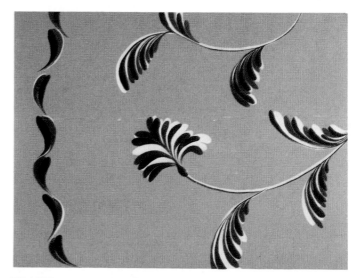

PLATE 12: Douglas-Gardner House
Hall and stairway.
Courtesy Mrs. Patricia S. Stewart and Mrs. Jeanne S. Muncey.

33

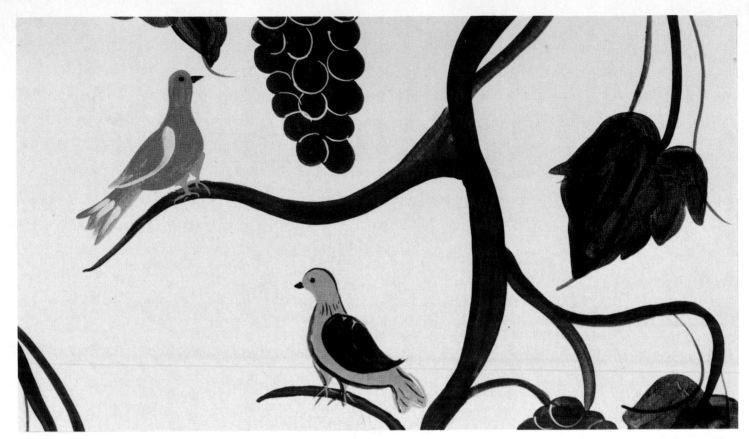

PLATE 13: Turner House
Parlor. Above chair rail.
Courtesy Mr. and Mrs. William Zullo.

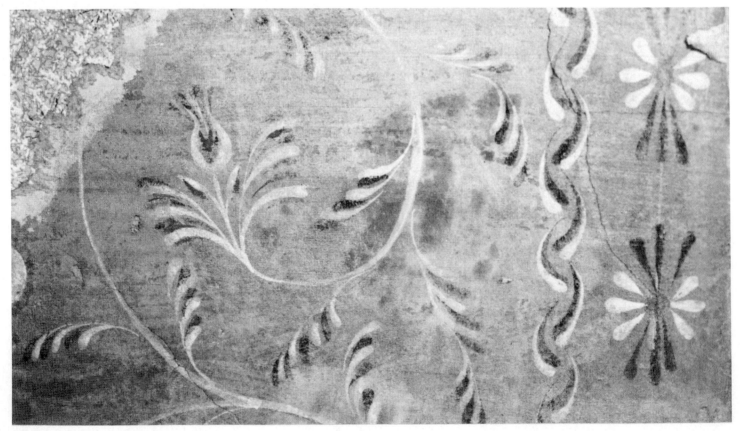

PLATE 14: Turner House
Upper hall. Above chair rail.
Courtesy Mr. and Mrs. William Zullo.

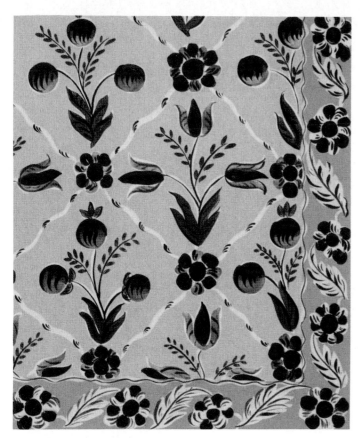

PLATE 15: Beach Tavern
Parlor. Above chair rail.
Courtesy Mr. and Mrs. Gene Burlingham.

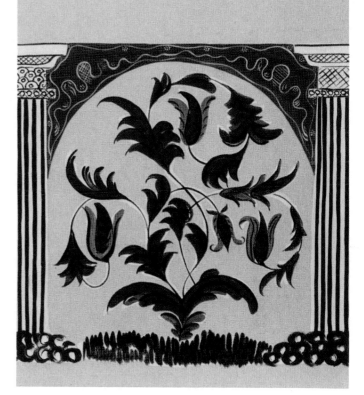

PLATE 16: Beach Tavern
Parlor. Below chair rail.
Courtesy Mr. and Mrs. Gene Burlingham.

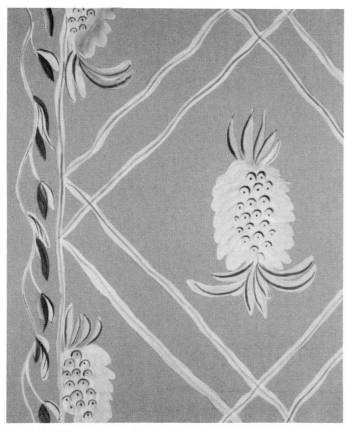

PLATE 17: Beach Tavern
Upper hall. Above chair rail.
Courtesy Mr. and Mrs. Gene Burlingham.

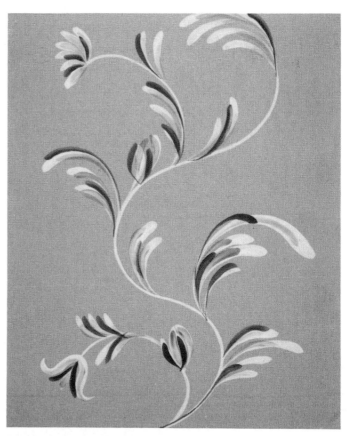

Plate 18: Beach Tavern
Upper hall. Below chair rail.
Courtesy Mr. and Mrs. Gene Burlingham.

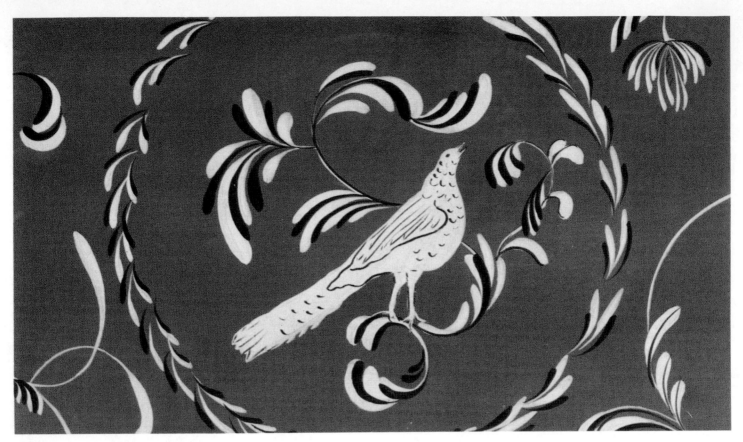

PLATE 19: Alexander House
Parlor.
Courtesy Mr. and Mrs. John Kiablick.

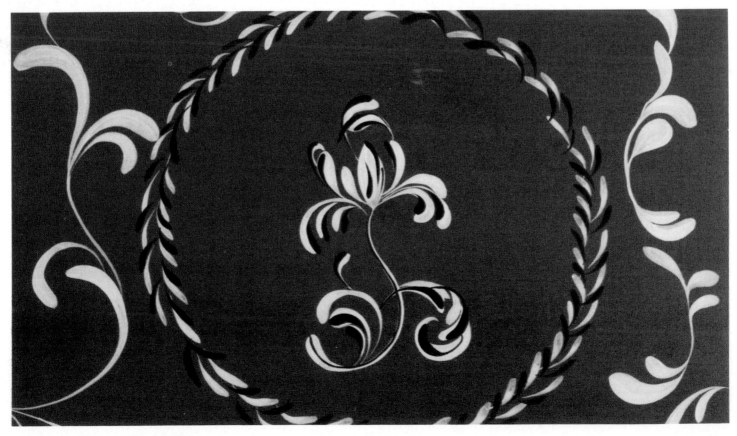

PLATE 20: Thomas French House
Upstairs chamber.

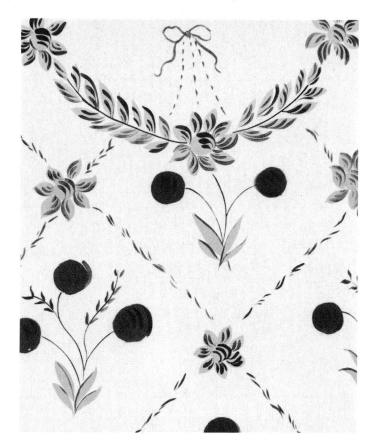

PLATE 21: Arms House
First parlor.
Courtesy Mr. and Mrs. Richard Arms.

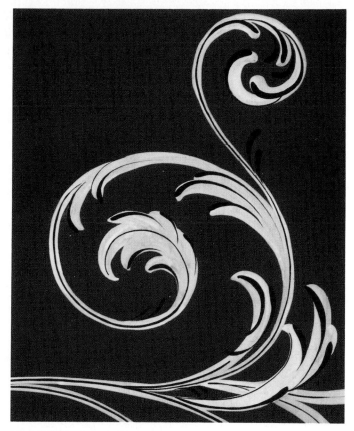

PLATE 22: Arms House
Second parlor.
Courtesy Mr. and Mrs. Richard Arms.

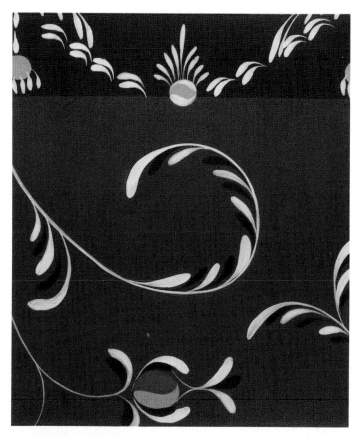

PLATE 23: Dillenbeck House
Front room.
Courtesy Mr. and Mrs. John Woods.

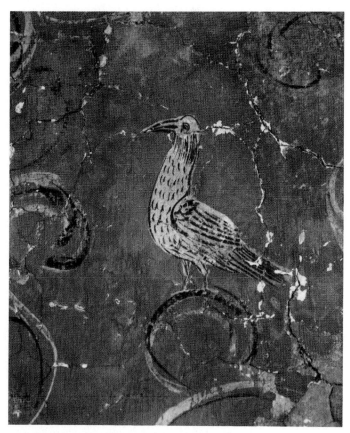

PLATE 24: "Landlord Abel" Chapin House
Taproom.
Courtesy Mr. and Mrs. Peter Goodman.

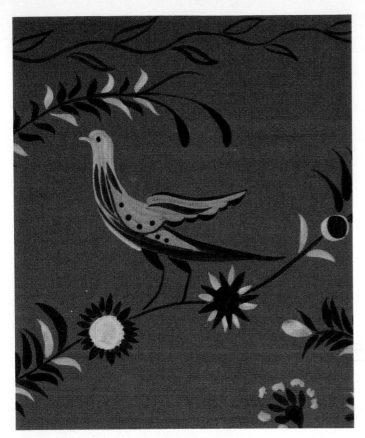

PLATE 25: Horton-Farrington House
First upstairs chamber.
Courtesy Mr. and Mrs. Charles Jakiela.

PLATE 26: Horton-Farrington House
Second upstairs chamber.
Courtesy Mr. and Mrs. Charles Jakiela.

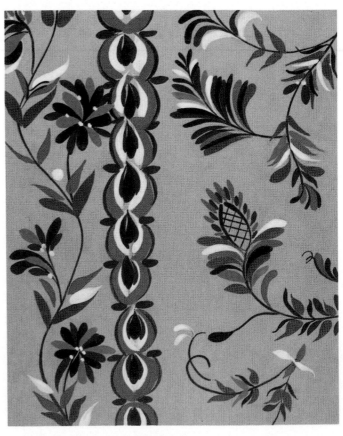

PLATE 27: Waldo House
Parlor or chamber.
Courtesy Mr. and Mrs. David Newell.

PLATE 28: Governor Jonas Galusha Homestead
Upstairs chamber.
Courtesy Mrs. Ranney Galusha.

VAN ALEN HOUSE—DeFreestville, New York, 1794

John E. Van Alen, whose home in DeFreestville has brush-stroke wall painting, was an active leader in his community. Born in Kinderhook in 1749, the son of Adam and Maria Van Alen, he married Anne, or "Nancy," Freyermoet in 1771. Nancy was the daughter of Dominie Freyermoet of Kinderhook, who preached in Schodack Landing as well, beginning in 1770. John and Nancy had no children of their own and adopted Evert, a nephew. John was a storekeeper in Schodack Landing at the time of his marriage, when he also appears on the register of the Schodack Landing Church. Evert, who married in 1777, seems to have lived in DeFreestville at that time.

According to Van Alen correspondence, the spacious home, which still retains its park-like grounds, was begun in 1793 and completed the following year. A memento probably displayed in the mansion's parlor was a pair of sugar bowls carved from coconut shells and mounted in silver. These were a gift to Mrs. Van Alen from Martha Washington for some unknown courtesy, extended perhaps when General Washington traveled north to Lake Champlain and returned through the Hudson Valley. Mrs. Washington explained that she, herself, had received the bowls

from an Indian chief. In 1793 John E. made his will, designating Evert as the heir to his new home and bequeathing to his nephew Andrus, "son of my brother-in-law, Nicholas Kittle," the sum of twenty pounds. Whether or not Evert moved into the house at its completion and shared it with his adoptive parents is not clear. He did not actually inherit the property until John E.'s death in 1807. It seems probable that the wall painting was done either upon the Evert Van Alens' moving into the home in the 1790s or when Evert became the house's owner in 1807.

The painting uncovered is in an upstairs chamber, although I suspect that at one time there was ornamentation in other rooms (Pl. 8). The design consists of two different borders along lines of construction and is of especial interest because it poses certain questions. Some brushwork is professional in appearance, skillfully applied. A second border, obviously similar in design to one used in the Van Ness House in Kinderhook, is less exact. Is this the work of two people, perhaps a master and an apprentice? Alternatively, if the poorer craftsmanship in one place is the work of an amateur copying a design from the Van Ness House, why is the second border so well done?

SCHERMERHORN-PRUYN HOUSE—Kinderhook, New York, 1713 and 1790

This brick-and-clapboard Dutch home sits on a high bank above the Kinderhook Creek. Built for Cornelis Schermerhorn in about 1713, the house became the property of Arent Pruyn in 1736 and was owned by his descendants until the 1850s. The house was really two houses joined by a later structural addition. The first building had two rooms with clapboard sides and brick gable ends. The dining room, where painting was found on a crumbling chimney-breast, is part of the structure added during the late 18th century which connected the two older buildings.

Only a sample of the Scroll Painter's decoration remains on shards of plaster (Pl. 9) preserved by the present owners. A frieze shows a rather sophis-ticated border with a carnation-like flower reminiscent of a motif that appears in a pattern found in the Van Ness House. Brush strokes connecting the flowers resemble strokes in a frieze at the Kittle House (Pl. 10). The brownish background paint resembles that in the Van Alen House in DeFreestville. The carnation is pink, the foliage green. Brush strokes are the familiar black and white.

Fine early architecture and beautifully detailed interior and exterior woodwork are common in Columbia County. Residents have long respected their architectural heritage and maintained the county's historic buildings appropriately. It is not surprising to find several brush-stroke paintings in this section of the state.

KITTLE HOUSE—Muitzeskill, New York, circa 1760

The clapboard story-and-a-half farmhouse in Muitzeskill, New York, known among local folks as the Nicholas Kittle House, was built in the mid-1700s, although roof overhang and windows, the latter no longer multi-paned, were altered a hundred years later. Spaces between uprights of walls behind the plaster were insulated with mud, saplings and straw. The house sits sedately on a knoll facing the west with a windbreak of tall trees.

Both Dutch and Palatine German families made up the roster of original white settlers in the Muitzeskill community. One old story says that the wife of an early Dutchman lost her cap or "musje" in the creek ("kill"), and thus the village was named. Another source suggests that "musje" can also mean a small measure of brandy, so we are allowed to choose our own interpretation of the hamlet's name. A 1767 map shows two houses owned by Nicholas Kittle, one of which has been razed, another house which was owned by Casparus Springsteen, and a fourth belonging to Hansie Van Valkenburgh. By 1781 Nicholas had left his residence to his son Johannes, who lived there for

some time, then passed the home on to his son John, "the farm with all its buildings, a cider mill and press, and all the provisions of beef and pork which I may have put up for my family." It seems pertinent to remember, too, that the Kittles and the Van Alens were related. (The Van Alen ornamented walls are in a house in nearby DeFreestville.) Nicholas Kittle and John Van Alen were brothers-in-law, having married sisters, Hittetjie and Anne, the daughters of Dominie Freyermoet of Kinderhook.

The parlor of the Kittle home has remnants of a brilliant blue-green wall and the Scroll Painter's motifs scattered at random from ceiling to floor.(Pl. 10) The palette is his favorite black, white and vermilion. There is a frieze of swags and a simple brush-stroke border around door and window frames. The wall painting was papered over, but much of the paper has been removed. It would seem that the decoration was done while Johannes lived in the house with his wife Eiche Moor Kittle because of the date of the painting in the Van Ness home (1797) by the same "hand."

HUDSON HOUSE—Malden Bridge, New York, circa 1790

On the Albany Turnpike near Malden Bridge in Columbia County, New York, a brown shingled house sits on a knoll. There was once a turnpike gate near this home, the residence at the turn of the 19th century of Samuel Hudson, Captain of a local militia group. The will of Revolutionary War veteran Elijah Hudson, who died in 1799, instructed that Samuel, who was then thirty-four, could "keep the house" purchased by Elijah when the son of his first marriage wed. (Elijah could afford his generous gift: he was one of the founders of the Canaan Federal Store, the first such emporium in the area.) Samuel and his family lived here on the turnpike until 1829 when, upon Samuel's decision to move west to Indiana, the property was conveyed to Isaac Van Alstyne.

The wall painting uncovered recently at the Hudson home is in a front room assumed to be the parlor (Pl. 11). Only remnants of the painting remain on some walls, perhaps because of changes in partitions. There is a wide chair rail, and patterns differ above and below this divider.

The painting again looks like the work of the Scroll Painter: there are curving "vines" and brush-stroke flowers and leaves. An undulating line with dots along it borders the outside edges of the overall pattern, and there is also the familiar band of color around door and window frames, this time the color of brick dust. A brush-stroke design ornaments the pinkish band. (A stripe lined with contrasting dots is an important embellishment in the entry hall of the Martin Van Buren National Historic Site, and is used again to encircle the harbor view above the mantel of the Beach Tavern ballroom. Pink bands beneath brush-stroke borders are also evident at Beach Tavern.) A unique bit of pattern gives evidence again of our painter's whimsy: half a cow, head down as if browsing, is cut by a window frame which has no border of design. Perhaps this window was added after the wall was painted. The Scroll Painter has used his favorite palette here: strokes are black, white and vermilion against what appears to have been a yellow background.

DOUGLAS-GARDNER HOUSE—Stephentown, New York, 1766

In 1766 a group of staunch Baptist families from Rhode Island migrated to Stephentown, York Colony, an area which came to be known as Jericho Valley. The Douglases, the Gardners, Nathan Rose, Elnathan Sweet, Edward Carr and John Mills were among these early settlers.

In a house set square on the points of the compass which stands today on Pease Road, wall decoration which resembles that of the Scroll Painter is still visible.

The oldest part of this house was erected in 1766 and may have been the original Asa Douglas home. Douglas purchased a portion of the King's Grant, once a part of Hancock Township in Massachusetts. Asa's son William and William's son Benjamin were also known to have lived on this parcel, perhaps in the Pease Road house. Many of the Douglases were Tories; folklore of the community tells of a Douglas paroled in his own home by Patriot neighbors.

In the 1840s members of the Gardner family purchased the property from the Douglases and added a section on the back, the size again of the original building. In the charming old section of the house, floor boards and plank partitions are still eighteen-inch-plus boards. Special closets are tucked into small places, one to hold ordinary preserves, another for special treats like wild strawberry jam. The house is large, a solid building with square roofs, big enough for two families to share. In 1870 "Uncle Kirk" Gardner, whose descendants own the house today, modernized his home, a typical custom as homes pass from one generation to another. Kirk Gardner added a Gothic gable on the front. Four slender colonettes support the gabled two-tier veranda. Possibly the decorative octagonal slate roof was also provided at this time.

The building's history is fascinating: once the oldest part housed a school. In the mid-1880s Saratoga Springs' Dr. Bedortha, famed because of his Water Cure Establishment, was a frequent guest of the Gardners. He treated a family member who was wrapped alternately in hot, then cold, wet sheets, and dosed with dandelion pills.

The painting which is visible today ornaments hall and stairway areas (Pl. 12). Background paint is yellow, on old plaster. There are circular "frames" surrounding varying sprays of brush-stroke flowers and foliage. Decoration is black, white and vermilion. There are more borders here than usual, all variations of brush-stroke combinations. There appears to be an overmantel painting in one parlor, but only a few motifs show faintly; most is beneath wallpaper. An elegant bonus may appear when on some future day this wallpaper is stripped!

TURNER HOUSE—Hoag's Corners, New York, circa 1790

Turner's Hill near Hoag's Corners is the site of a large farmhouse into which John Turner (1766-1849) moved his family in about 1790. The records say he "located very early in the extreme east part of the town." This area had been the site of an earlier Indian village, Ontikekomuck, to which white missionaries were sent. There were early turnpikes through here, one from Stockbridge to Nassau, and another from East Nassau through Hoag's Corners, perhaps to Lansingburgh.

At a town meeting in 1806 held at Pliny Miller's inn, Jonathan Hoag was appointed Supervisor and John Turner one of the Fence-Viewers. At about this time the town fathers agreed that "rams running at large between the first day of September and the tenth day of November shall be forfeited to any person taking up the same."

John Turner's first wife, Catherine, died in 1832. His second wife, Mary Ann, died in 1842, according to her gravestone in the little family burying ground where fifteen graves still remain just up the road from the house. Mary Ann's marker identifies John as "Reverend" and there is a tradition that at some time the home was used as a church.

The present owner remembers that when she moved into the house there were Bibles and other books painted upon the wall in the parlor as if at rest on the mantel shelf.

The creativity and adeptness of the Scroll Painter are once again evident in this farm home. A downstairs parlor, the ornamentation of which was discovered recently under wallpaper, has grapevines covering the walls, lush with foliage and fruit (Pl. 13). The vines grow vertically and have shoots going off horizontally at regular intervals so that the vines divide the space into squares of pattern. Small, once-bright birds fly, sit on the vines, and nibble at the grapes. Although wallpaper has been removed, discolored paste lingers, making the wall so dark that it is impossible to determine what the background color was. The same elongated rosette, in different color combinations, appears in a border in each painted room. Alternating brush strokes define the border.

Other decoration here is in an upper hall along the stairwell (Pl. 14). Background in this section is gray. As frequently happened with wallpaper, different patterns appear above and below the chair rail. Immediately below the simulated chair rail and just over the baseboard are rosette and brush-stroke borders like those described in the parlor. In this instance the design is dramatic in black and white with vermilion dots at the centers of the rosettes. The major decoration below the chair rail consists of white urns about eight inches high at intervals of two feet, with a decorative "rope"

hanging between, a white wreath caught at the middle. The Turner House is the only one among these houses in which such a design has been discovered. (See also, though, the newly uncovered, below-chair-rail pattern in the Beach Tavern parlor, Plate 16.)

Above the chair rail are tight, concentric swirls close to each other, not as free-flowing as the designs in the Van Ness or Van Wormer parlors. Foliage brush strokes of black and white, as usual, grow from white vines. There are vermilion accents giving dimension to a variety of flowers including Dutch lilies and another shape which might represent a wild rose or dahlia. The hall has a repeating frieze motif, a thin white scallop with alternating pairs of black and white leaves. The black leaves are accented with white strokes down the center, the white leaves with vermilion strokes. The ceiling in the hall has been lowered. If there was a pattern at the very top of the wall, it is no longer visible.

It is in this home that scribed marks in the plaster can be distinguished, creating guide lines for borders and scrolls.

FIG. 13: Design below chair rail in Turner House. Black and white on gray.

DILLENBECK HOUSE—Canajoharie, New York, circa 1806

Painting in the Dillenbeck House on Stabenow Road near Canajoharie is evidence that the Scroll Painter crossed the Hudson and may have worked in many homes along the Mohawk. This story-and-a-half building, another one-time stagecoach stop, was built by John J. Dillenbeck, probably in 1806. The farmsite is perfectly situated, at the top of a hill with good drainage for the fields and a vista extending far toward both the east and the west. John J. was born in 1776 in Stone Arabia, New York, married Maria Elizabeth Seeber, whose rural home was near Canajoharie, and settled in Marshville, close to her childhood home. The couple had twelve children. John J. was an active member of the local militia, serving as an ensign beginning in 1798 and as a lieutenant in 1805, when he was a member of Colonel Andrew Grey's Regiment.

The wall painting here was covered with wallboard in the process of insulating the house. There is also new siding on the L-shaped structure which at some point had a little room added to jut out where a wing joins the main building at the front. A bay "picture window" has been installed in the main section, perhaps in the place of the original front door. Painting decorated the walls of what must have been the common room of the early inn (Pl. 23).

Background wall color is again the reddish shade of old bricks; the design covers the entire wall from floor to ceiling. There are bands of color above baseboards, around window and door frames and at the tops of walls, as in the Van Wormer parlor, in this case of rich brown with running borders on the contrasting band. At frieze level there are swags, perfectly symmetric as in the Van Ness and Van Wormer Houses. In this sample of the Scroll Painter's work, he placed his brush-stroke foliage more often than usual on the *inside* curve of the vine, rather than on both sides. Most brush strokes are black and white although some strokes of rich pink and others of yellow ochre can be seen. It appears that the ochre has not held well; probably many more golden-yellow strokes were used originally than were evident when the wall was photographed. Scrolled vines are white.

BEACH TAVERN—East Bloomfield, New York, circa 1800

In East Bloomfield on the early toll road, the main east-west route through New York at the turn of the 19th century, stands a building known as early as 1805 as a tavern. The property was owned by one Ashbel Beach, who, according to an 1810 census, lived at this site, earlier referred to as Homestead Farm. It is suspected that there was a brick factory on Mud Creek, which runs in back of the house, and the lumber for the building, cut with a pit saw, was probably produced in the early sawmill which stood on the bank of the creek.

The Beach House stands impressively on a side hill and has several unusual features including a spring floor in the second-floor ballroom and a unique bin in the front entryway. The shallow recess in the front hall commands the visitor's attention immediately. Tradition says this once held a grain bin, handy for feeding horses while stagecoach passengers alighted for a meal. Oat chaff discovered beneath the floor helps to substantiate this legend. According to records of the 1830s, the "Brick Tavern" accommodated between thirty and forty travelers at a time, many in a large second-floor room which served as a dormitory.

This former inn is being restored today. In the process, the owners, Gene and Mary Burlingham,

have removed wallpaper to find wall painting in the parlor, in the lower and upper hallway, and in the former ballroom (Pls. 15, 16, 17 & 18). The itinerant painter or team of painters must have spent weeks here. Design in the entry hall is busy, an all-over pattern with an orange-salmon background divided into segments by black and brown solid lines, dotted lines, and arches. The motif of major interest is a vermilion, ball-like blossom with brush-stroke foliage at each side.

The second-floor ballroom has an overmantel like that at the Arms House in Deerfield. Similar ones have also been found over the years in the former Waid-Tinker House in Old Lyme, Connecticut, now destroyed by fire, the Tyler-Harrison House in Northford, Connecticut, the early Ryther or Burrows House in Bernardston, Massachusetts, and the Burk Tavern in the same community. (The latter overmantel is now exhibited at Memorial Hall in Deerfield, Massachusetts.) The Ashbel Beach Tavern overmantel shows a village and a harbor with ships, the "Lydia, out of New York" and the "Nancy, out of Boston." The Beach House ballroom has a bonus, another portion of wall, now dim, with houses and streets depicting a further view of a village. This is above chair rail height. In the upper hall, below a chair rail, there

are more scrolling motifs, these with a color scheme not seen elsewhere. All of the pattern was first painted in white, then deep red, yellow ochre and Prussian blue overstrokes were added, giving a patriotic effect. The Prussian blue has replaced usual black accents. Although this wall has been papered over and the paper removed, these colors remain quite bright. Above the chair rail another type of pattern appears; against sand-colored plaster, white wavy lines cross, forming diamonds, a pineapple centered within each. Thin black accents are almost gone; the pattern which remains is pale blue with white. The effect is deli-cate and charming. Originally there was red, at least in border units, and black accents added dimension and drama. The pineapple motif is unusual, resembling only one other wall within memory, that of the H. W. Gray House in Old Lyme, Connecticut. The Gray House once had a brush-stroke-painted design on deep red with tulip, ball flower, and hyacinth motifs with wavy lines. The hyacinths were treated much like the Beach Tavern pineapples.

The most recently uncovered wall painting is in the parlor, where a restorer/woodworker was working on the windows. The walls now revealed

FIG. 14: Notice hyacinth motif from H. W. Gray House, Old Lyme, Connecticut, similar to pineapple motif in Beach Tavern hall. Photo courtesy National Gallery of Art.

48

are light ochre, the decoration divided into diamonds with wavy white lines. These have random clusters of delicate brush strokes in black which add dimension and interest. Centered in each diamond is either a three-tulip motif like that at the H. W. Gray House or the three round flowers like those in the Wilcox House (Fig. 21) and the Arms House (Pl. 21). At each intersection of white lines there is a blossom in full bloom with alternating red and blue petals given shape by tiny black brush strokes. The border around most lines of construction is more elaborate than usual. The frieze is colorful and detailed. The background bands under borders are pink. In this room, too, the Scroll Painter first painted his carefully measured pattern in white, then added the color which makes the design come alive.

The overmantel painting in the parlor fits its setting perfectly. Here there are three urns, the center one larger than its sisters. The bouquets are what one would expect from the Scroll Painter: the sweeping white stems and foliage with their brush-stroke accents are adapted from all-over wall patterns. Colors are bright, flowers and leaves covered with a filigree of tiny strokes. This vivid, stylized overmantel painting is in complete contrast to the second-floor ballroom overmantel with its harbor and village scene. The overmantel is framed by the narrow pink band and a brush-stroke border which follows lines of construction around the room.

The other important feature of this room is the amazing architectural design covering the dado (Pl. 16). There are tall columns with marvelous detail (including capitals that vary) and alternating designs within arches—trees and a scroll pattern. Among recently documented homes, only the Turner House has a similar dado. However, Edward Allen showed photographs of architectural dadoes in the Waid-Tinker House in Old Lyme, Connecticut, and the H. W. Gray House, also in Old Lyme. The Waid-Tinker House is no longer standing. The dado in the Gray House had been repainted in an effort to replicate the original by the time Allen's pictures were taken. Its similarity to the original dado painting still visible at Beach Tavern, however, is obvious.

The variety of motifs used in the Beach House again suggests either that the Scroll Painter was a gifted designer as well as a skillful craftsman, or that two artisans were working together. The kinds of patterns mixed here, along with the overmantel paintings, are much like those found in the Arms House in Deerfield, Massachusetts, as well as those found in Connecticut buildings documented previously by Allen, and are clearly the work of the same painter or painters.

FIG. 15: Upper half of overmantel painting in Beach Tavern ballroom. (Note stovepipe hole cut into painting.)

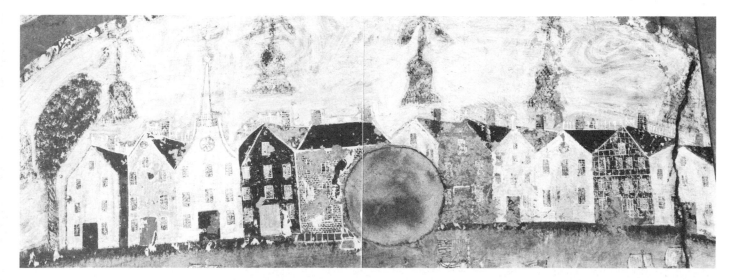

49

FRENCH HOUSE—Conway, Massachusetts, circa 1760

The early settlers in Conway, Massachusetts, were at first dependent for services upon neighboring towns; they carried grain to the mill in Deerfield and went there or to Hatfield to hire oxen for spring plowing.

The Thomas French House in Conway is large and sturdy, an 18th century building which was once a tavern. French (1732-1813), its first owner, had been an innkeeper in Deerfield before he and his wife Miriam Billings French moved their family and possessions over the hill to Conway, where French had acquired Lot 76, one-third of the way up Arms Hill. There they built the inn, which was later moved to its present site at the foot of what is known today as Baptist Hill. (A Baptist church was erected where the tavern once stood.)

Thomas French has been described as "a great man in those days," his inn a "place of great resort." The tavern owner was rich compared to his contemporaries, able at one time "to walk from Conway to the Deerfield line on his own land." At a time when the community consisted of one hundred eighteen households and farmers owned a total of fifty-two horses, Thomas possessed four of these, more than any other individual. When one hundred forty-eight cows made up the bovine population, French owned eight. Of the communi-ty's two hundred fifty-eight sheep, sixteen were in the tavern owner's flock. Thomas and Miriam's family grew, too: Tryphena, Tertius, Achsah, and Patty were among their offspring.

Like other early tavernkeepers, French was interested in politics. Hostelries often served as community centers, and Thomas offered his inn for Conway's first town meeting in 1767. Over the years he filled many offices, including those of Selectman and Assessor, along with Samuel Wells and Consider Arms, appointed at the first official gathering. French later was Surveyor of Highways and a Fence-Viewer. In wartime he was one of the town officials appointed to answer Boston's Committee of Correspondence pamphlet. In 1772, French, now referred to as "Captain," was sent as a delegate to Northampton to attend a meeting of the Superior Court "in order to form a Convention."

What happened to change Thomas French's habits and his reputation in his own community is a mystery. Perhaps the opportunity to become a wartime profiteer was too difficult to resist. A contemporary suggested that he became proud and officious, writing his name "in great letters" in the town record book. A local history explains:

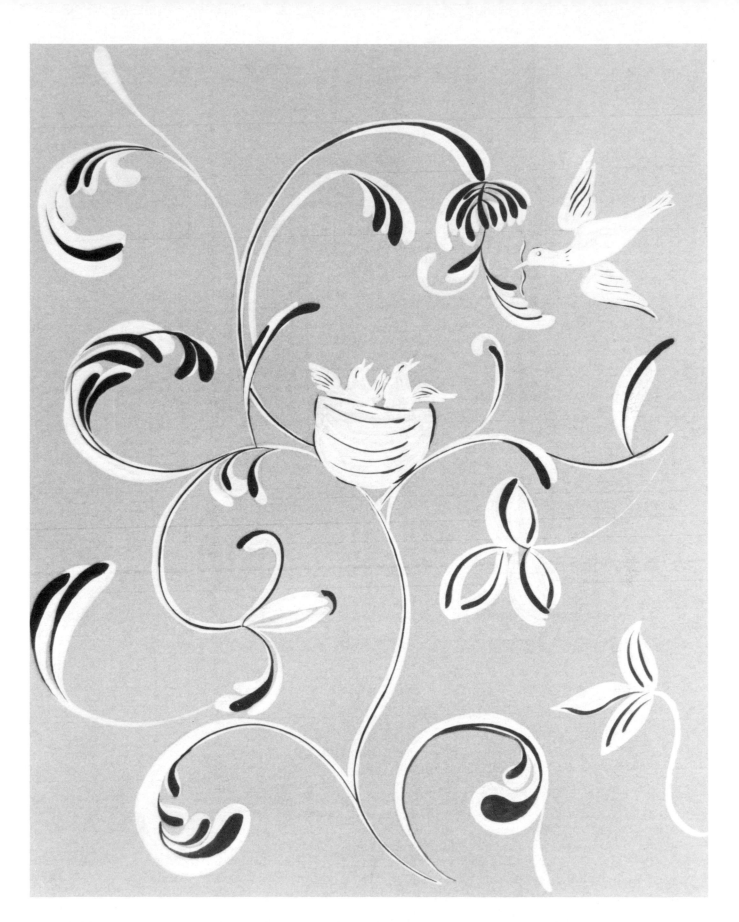

FIG. 16: Charming motif found in both French and Alexander Houses.

...he fell into idleness, cheated the Continental government in salt, took to the lawyers, forged, sat in the pillory, and died a vagabond. French's death occurred in 1813.

There is no indication of when the walls of the French tavern received their bright decoration. To match the dates of other such painting along the Connecticut River by the same painter, this should have occurred sometime during the last twenty years of French's life. Designs remain in an upstairs chamber and in the stairway hall leading to it. The ornamentation in both rooms is colorful and carefully executed, the work of the Scroll Painter (Pl. 20).

The plaster of the hallway is painted a soft gray. The brush-stroke motifs are in contrasting black and white. Here there are sprigs of foliage and a bird's nest with a parent flying toward it, a worm in its beak. The painter also showed his whimsy when he sketched a vase to sit upon a jutting shelf of masonry over the stairs. The painting here is in good condition.

In the master bedroom the walls were once the color of pink brick, a warm and vibrant shade. The woodwork in this room, as throughout the house, has magnificent architectural details. White paint on woodwork contrasts with the deep color of the walls. Some plaster has needed repair, but much of the original painting still exists. The decorator chose to frame motifs with circles of brush strokes. On either side of the fireplace he painted marvelous birds of indeterminate species. Decoration again is in black and white only and in both rooms extends from floor to ceiling, rather than above chair rail only.

FIG. 17: Detail of Stratton Tavern wall. Black and white on gray.

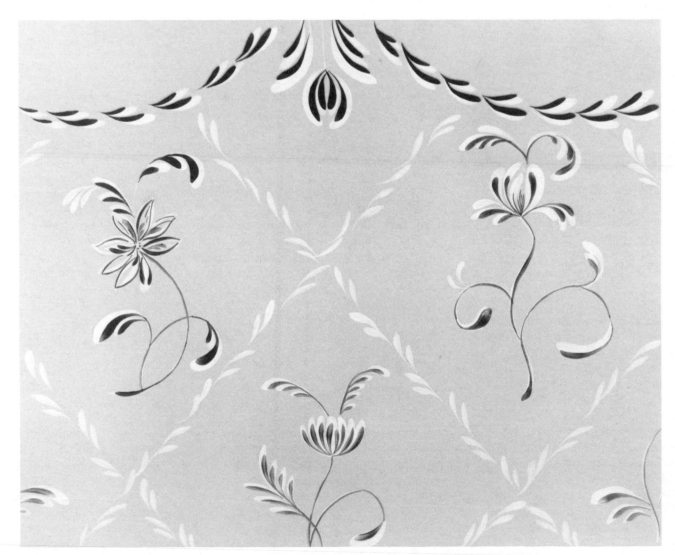

STRATTON TAVERN—Northfield Farms, Massachusetts, circa 1762

The home of five generations of the Stratton family, familiarly known as Stratton Tavern because for several generations it served this purpose, is now locked and barred for safety's sake, awaiting eventual removal to Old Sturbridge Village. It is today an empty, sturdy-looking, hip-roofed, two-story building with an ell on the back. The roof line has been changed. Earlier photos show a straight steep-pitched roof. Long-time teacher and local historian Elsie Scott of Pentacost Road in Northfield remembers that "one floor had a design...and a room had stenciled walls." (These decorations are in addition to the brush-stroke painting which will be described here.) Also from Miss Scott: "Corner beams inside show and are wider at top than at the floor. Front stairs are opposite the front door, steep, and start up west, then south, then east, if I recall. Rooms are large. There is a room for cheese curing... clapboards are fastened with hand wrought nails." There is no longer a chimney, and a once-attractive doorway with slim pilasters and decorative details over the entry is now sheltered by a piece of tin roofing which covers the lintel.

Stratton Tavern is near Northfield, Massachusetts, in a locale once known as Northfield Farms. The inn is only a short distance from the Connecticut River, which flows 350 miles from the Connecticut Lakes in northern New Hampshire to Long Island Sound. This north-south route provided vital transportation for flatboats during the 18th and 19th centuries, when first-settled areas in Connecticut and Massachusetts became crowded, and residents, especially of the Nutmeg State, migrated into northern Vermont and New Hampshire. Very early a road wound along the river so that stagecoaches and farm wagons could carry travelers and farm produce. Taverns at this time were of as much importance to local folks as to travelers. Here they could gather for pleasure or for discussion of local affairs between more formal town meetings.

Hezekiah Stratton, Jr., acquired the site of the tavern in 1757, when his father's estate was settled. Thirty-one years old and married to Molly Smith, this second Hezekiah built the tavern and applied for the required annual license from the county court. This was granted in 1763 (the French and Indian disputes were just ending), and he was allowed to become "Innholder, Retailer, and common Victualler in his dwelling house" for the following year. It has been recorded that this Hezekiah "at the Farms" was the possessor of a fine "two-horse hack." This first Stratton innholder kept his license current only until 1774 and the beginning of the Revolutionary War. At this time he became even more active in community affairs and served on a committee "to enquire

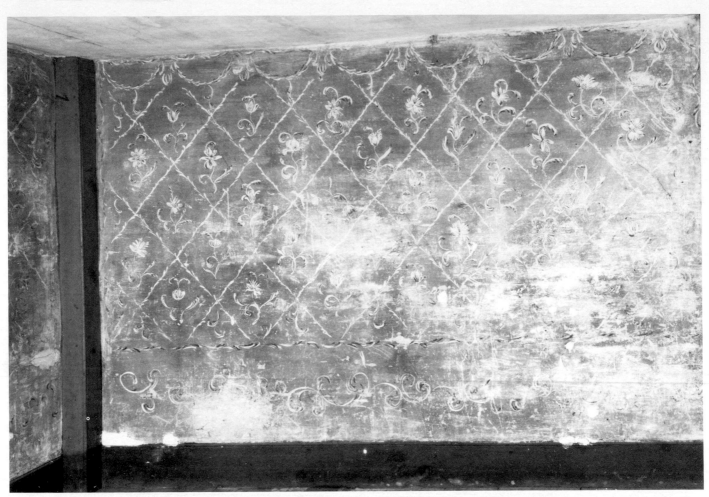

FIG. 18: Wall in Stratton Tavern upper chamber. Photo courtesy Old Sturbridge Village, Inc.

into the circumstances of families whose husbands are gone into Continental Service, and provide them with meat and grain at the price such articles sold for when they severally enlisted into the Service." In 1779 he served on the Committee of Correspondence and was several times a local Selectman. We are reminded by a note in Northfield records that although the village had grown, at the end of the 18th century Northfield Farms was still untamed. Hezekiah (probably the third) killed a wildcat on December 4 and another on December 27, 1799.

In 1788 Stratton Tavern was again licensed, this time under the management of the third Hezekiah, who was twenty-two. (It is interesting to note that the Strattons contradict our established ideas of primogeniture, for the *youngest* sons in their families usually carried on the family name and business.) Hezekiah married Hannah Wright in 1789, and in 1790 their first son, Charles, was born. The senior Hezekiah and his wife shared the family home until his death, when his widow remarried and moved away from the tavern. The third Hezekiah was a land speculator and had acquired considerable property before he inherited the tavern, owning over five hundred acres, chiefly near Stratton Tavern, by 1798. Young Hezekiah served

as an innholder until his death in 1825. It was during the tenure of this Stratton that additions were made to the tavern and the carefully executed brush-stroke wall painting probably done.

The wall painting which remains is in a second-floor chamber. The background is a light gray and the painting shows motifs by the Scroll Painter, a composite of designs seen in other houses along the Connecticut River and in New York State. Of especial interest is the scroll pattern found above the baseboard, mimicking a very similar one, also over the baseboard, in the Van Alstyne home in Kinderhook. Designs cover the wall from floor to ceiling. Broad spaces are divided into diamonds as in the Van Wormer House; these diamonds are of larger dimension but also filled with single floral motifs, many of which are tulips. The painter seems to have used only black and white brush strokes. The frequently used frieze of meticulous swags defined by brush-stroke edgings completes the ornamentation perfectly. A cluster of brush strokes hangs between each of the swags. The observer is struck by the painter's mastery of design techniques which allowed him to put varying motifs together in an especially appealing composition.

ALEXANDER HOUSE—Northfield, Massachusetts, circa 1774

The Simeon Alexander House is in Northfield Farms, just down the road toward Northfield from the Stratton Tavern. This was originally the home of Simeon Alexander and his wife, Jerusha Stratton Alexander, daughter of Hezekiah Stratton, Jr., and sister of the third Hezekiah, who, in 1788, started to operate Stratton Tavern for the second time. Jerusha was a twin; her sister Eunice married another Alexander, Medad, cousin of Simeon. The Stratton twins married the Alexander cousins in 1780 when the girls were twenty years old.

The Alexander House resembles the tavern architecturally. It is large and two-storied. Today it, too, has a hip-roof which was once steep-pitched and straight. The window pattern throughout the building is similar to that of the tavern; across the front are the same five windows on the second floor with two on each side of the entrance at ground level. Wall painting, the work of the Scroll Painter, can still be distinguished in only one room, probably once a parlor (Pl. 19). The background paint is ochre, now quite faint; the design, like that in the second-floor chamber of the French House, has some motifs framed in brush-stroke circles, with other flowers, birds, and foliage placed at random about the walls. Blossoms are reminiscent of those in the Kittle House. Birds have a jaunty air. There is a nest of baby birds with an anxious parent flying to feed them—like the motif at the French House (Fig. 16). The frieze looks exactly like that at the Stratton Tavern, and here, too, decoration is entirely in black and white.

FIG. 19: Three birds and half a cow.

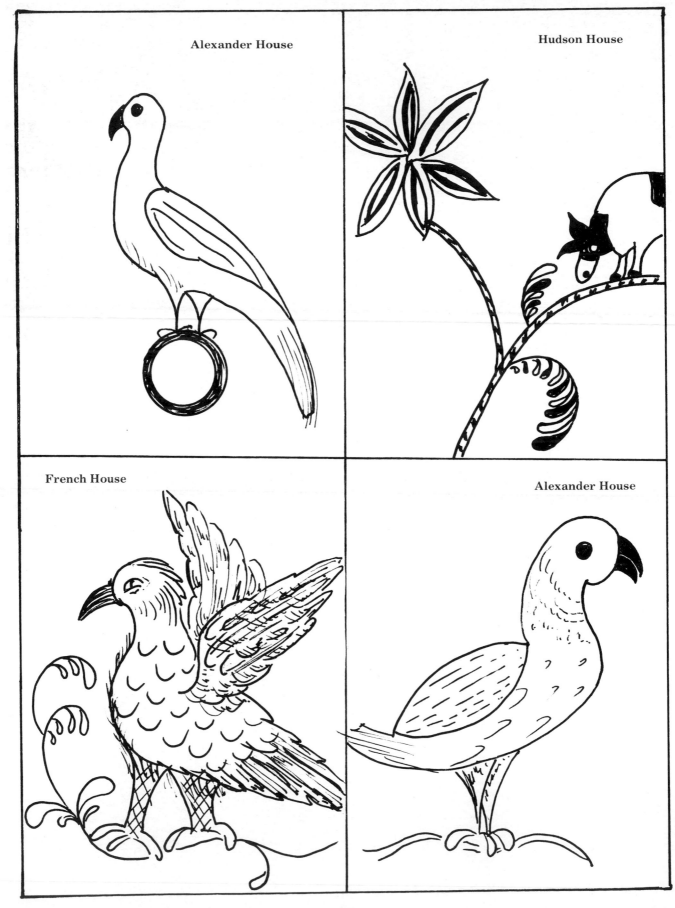

Alexander House

Hudson House

French House

Alexander House

ARMS HOUSE—Deerfield, Massachusetts, circa 1750

This solid 18th century house welcomes visitors who enter historic Deerfield Village from the southeast. The older back section of the home was built for Jonathan and Edward Allen. Later acquired by the Samuel Childs family, its ownership passed in 1809 to Christopher Tyler Arms and has remained the property of the Arms family up to the present.

There are traces of wall painting in the two front rooms (Pls. 21 & 22). A parlor to the left of the entryway has walls of dusky pink, once probably brick red. Here there are traces of white scrolling in an all-over pattern, tailored to fit special spaces, such as those between windows. Fortunately for the researcher, this wall was traced years ago and the tracings have been carefully preserved. These provide the opportunity today to imagine the room as it once was. The decoration, apparently the work of the Scroll Painter, was painted in white with accents of black, red, and blue against the deep brick-colored background.

At the right of the entry hall, in a spacious second parlor, there is an overmantel depicting ships and houses along the shore. This has turned dark with age and soot and is no longer distinct. It is the work, however, of a painter known for similar paintings in Northfield and Bernardston, Massachusetts. The overmantel also resembles the one in the Beach Tavern in western New York State, suggesting a route westward which the painter or painters may have followed.

The overall design on other walls in this room is quite different from the scrolling in the first room described, and at first glance appears to be the work of a second painter. It is, however, another familiar pattern with diamond frames and the ball-like flowers seen in the section of wall from the Wilcox House, now in the New Haven Colony Historical Society in New Haven (Fig. 21).

FIG. 20: Wall originally in upstairs chamber of Williams House. Courtesy Society for the Preservation of New England Antiquities.

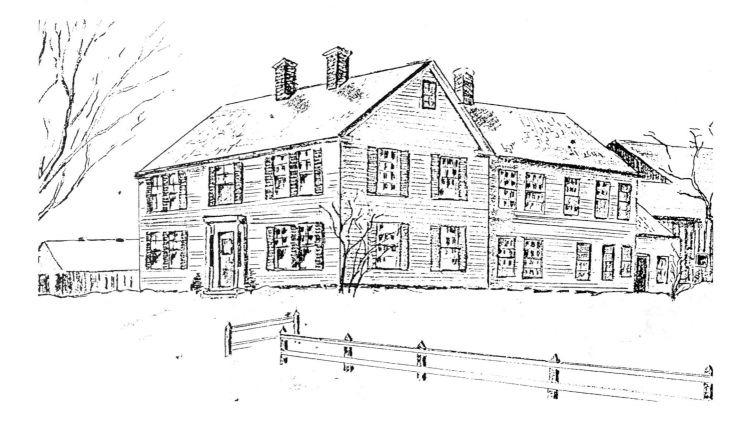

"LANDLORD" WILLIAMS HOUSE—Sunderland, Massachusetts, circa 1720

Sunderland, Massachusetts, is today a beautiful village with wide streets on the east side of the Connecticut River, in the west central part of the state. Once called Swampfield, the village was the early site of a ferry across the river.

Oliver Williams, Sr. (1748-1833), like "Landlord Abel" Chapin, earned the nickname by which he was known. He arrived in Sunderland "soon after 1770." (Local histories give different towns as the former residences of "Landlord Williams": Norwich and Ledyard, Connecticut.) In 1775 he married Zeruiah Ballard and that same year purchased an old house on the west side of town which had been built in 1719 or 1720. Williams was licensed to operate an inn in 1781.

Williams Tavern was razed earlier this century. Fortunately, wainscoting from the building with decoration by the Scroll Painter has been saved and is in the architectural archives of the Society for the Preservation of New England Antiquities, at the Harrison Gray Otis House on Cambridge Street in Boston.

Background paint on the Williams wall is gray, the motifs black and white. The Scroll Painter's skillful strokes look very much like the scrolls used to trim stagecoaches and other elaborately ornamented vehicles. This painting has been well preserved. It looks as though furring strips, lath, and plaster covered the wainscoting for years, protecting its valuable decoration.

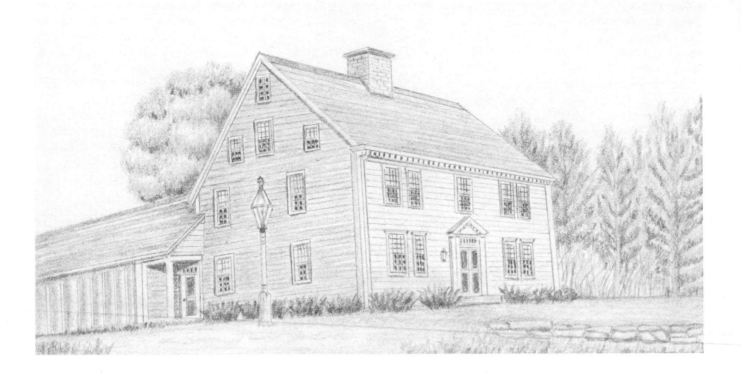

"LANDLORD ABEL" CHAPIN HOUSE—Originally in Chicopee, Massachusetts, circa 1725

The name Chapin is prominent among early settlers in south central Massachusetts, where pioneers purchased "the land along the east side of the Quettecot River from the mouth of the Chicuppy to the Wollumansuk" from the Agawam Indians in 1641. "Landlord Abel" was the grandson of Japhet Chapin, first settler in Upper Chicopee, and great-grandson of "Deacon" Samuel, a pioneer settler in Springfield.

Abel's home was built between 1725 and 1730, only a few years after his marriage in 1720. The handsome house combines characteristics of Colonial and Early Georgian architecture. It is three-storied with a center chimney and twelve-over-twelve windows. The lower front windows, on the first floor only, have cornices over the window caps. The entrance is impressive with pilasters at each side of the door, small panes of glass over the door, and a pediment above. There are modillions in the pediment as well as along the cornice. The house originally stood at 343 Chicopee Street in that city and was the first tavern in Chicopee. It was operated as a hostelry through several generations of Chapin ownership.

"Ensign Moses" Chapin inherited the house from his father "Landlord Abel," and the ensign's son "Major Moses" was given the place when his father died. Logic suggests that "Major Moses" would have married and inherited the house in the 1790s. It seems plausible that "improvements" may have been made at this time. Much of the Scroll Painter's work in this house is on wainscoting. Perhaps "Major Moses" had the wainscoting applied to the walls when other updating was done. The Chapin House now sits in a rural setting near Mill River, Massachusetts, having been dismantled, moved, and re-erected there in 1980.

Mrs. Clara Skeele Palmer says of the Chapin home, in Winthrop McKinstry's *Glimpses of the Past*:

> It was a well-built house; the rooms were all large and very low, but the mantels and panelling were all finely finished with fluting, and other similar ornamentation. Perhaps it had not ought to be called carving, but it was certainly hand work. The large kitchen in the "L", and the great fireplace were two of the principal features of the house.

Another feature is its fine painting (Pl. 24). This adorns the walls of a long room at the rear of the house. (It is easy to imagine travelers crowding before the wide fireplace here, sharing news and political views over hot toddies or mugs of cool ale.) Much of the wall painting, since it was on wooden panels, was moved from Chicopee to Mill River with very little damage. A decorated chimney-breast on plaster has also been preserved in good condition even though it was much more vulnerable to damage than the painting on wainscoting. The plaster-covered chimney-breast and the wainscoting were painted a shade of ochre. Again, the ornamenter's color chart consisted of white, vermilion and black, with brush strokes usually applied in that succession. There are charming black-and-white birds, much like those in the Alexander House in Northfield Farms, bold against the light-colored background. The painting in this house is marvelously, almost miraculously, bright and clean. The present owners are responsible for this fine condition, having spent long, tedious hours carefully erasing soot and dirt, the accumulation of almost two hundred years.

FIG. 21: Wall painting from Wilcox House. Photo courtesy National Gallery of Art.

WILCOX HOUSE—Westfield, Connecticut (date unknown)

The New Haven Colony Historical Society, like the New York State Museum at Albany, has salvaged a panel of brush-stroke-painted wall. The historical society's treasure is a section of wall from the Wilcox House in Westfield, Connecticut. The design is one which is familiar, sometimes seen in houses along with the graceful swirls that are the trademark of the Scroll Painter. The largest motif is a sprig of red and yellow ball-shaped flowers on a dainty black stem which is an S-curve. Leaves along the stem are simple outlines. The motif is within a diamond suggested by small, spaced clusters of brush strokes. A second motif looks geometric, an open star-shaped flower, with a red center and black brush-stroke petals. The frieze from this wall is similar to ones found on wallpaper borders of the late 18th and early 19th centuries. There are swags of impressionistic blossoms and foliage in bright colors: red, yellow and a green which has some brown in it. The swags in the frieze are separated by "rope." The top stripe defining the frieze is green, the lower stripe deep yellow with a narrow stripe of vermilion on top of it.

HORTON-FARRINGTON HOUSE—Brandon, Vermont, 1799

The two gentlemen who were successive owners of this post-and-beam home during the time when its walls were probably painted were prominent enough in local activities to allow us some picture of life in a new town at about the time when these charming wall paintings were first created by the decorator designated as the Border Painter.

The house was built for Judge Hiram Horton in 1799 in Brandon, Vermont, by John Conant. (Brandon, burned by the Indians in 1777, is a distorted contraction of "Burnt Town.") Horton was married to Sarah Drury, who over the years bore him six daughters and two sons. Horton was active in local government, described as "much esteemed for his intelligence and uprightness." He served as Town Clerk, Justice of the Peace, Selectman and Member of the Assembly. In a March, 1786, Town Meeting, when the community was new and Horton was Clerk, the officers voted to procure a minister for the town to be paid thirty pounds a year. Hiram was made a member of the committee to search for iron ore and study the possibility of building an ironworks to bolster the local economy. At this meeting new roads and other improvements were planned. By the fall of 1786, town officials felt the need to build stocks and erect a whipping post in the village, and voted also that "enoculation for the small pox during the

present spring" should not be permitted. When in March of 1800 a pauper was auctioned to the lowest bidder, Hiram offered to keep the indigent one-half year for eight dollars and was a winning bidder. In 1787 town fathers turned to other local matters and voted to allow hogs to run free if they had "a good ring in their noses." By 1797 an ironworks had been established in Brandon, along with forges which turned out "good bar iron." In 1809 Horton left Brandon to migrate to Malone, New York.

By this time the property belonged to Daniel Farrington, whose father, Jacob, apparently purchased the house from Judge Horton and retained ownership briefly. It seems an interesting coincidence that the Farrington family moved to Brandon from Kinderhook, where other brush-stroke-painted walls have been discovered. Daniel, thirty-six years old when he acquired his Pearl Street home, had married Lois Drury, probably related to Judge Horton's wife, in 1796, and joined the local militia as the War of 1812 approached. He was for a time stationed at Windmill Point, near Rouse's Point, on Lake Champlain. Captain Farrington did not take part in the decisive Battle of Lake Champlain in which the British were defeated, since he had been wounded while commanding the revenue cutter Fly in an engagement

on the Onion River near Winooski with the Black Snake, a large bateau engaged in a smuggling operation. Farrington has been described as "a discreet and competent officer."

Four generations of Farringtons occupied the two-and-a-half-story house on Pearl Street. The men were successful at raising merino sheep and operating their dairy farm.

In this Federal home with its entry porch incorporating reeded columns, wall painting remains in two upper chambers at the front of the house (Pls. 25 & 26). The decoration in one room is quite different from that in the other. The background paint in one chamber, though now quite worn, was originally bright pink. Here there are birds and borders, both in great quantity and variety. All the birds are different, portraying fascinating, unrecognizable species, casually framed by irregular vines with leaves. As in the Galusha House, there are myriad borders vying with each other to gain our attention. There is an overmantel painting here, with a patterned urn which resembles western pottery, holding a bouquet. Shadows of figures appear dimly on either side of the mantel shelf. The female figure at the right appears to have been defaced. Local folks suggest that this occurred when a widower remarried. If credence can be placed in this legend, the original painting was done when Daniel Farrington moved into the house. After his first wife, Lois, died, he remarried, and the painting could have been altered at that time.

The ornamentation in the second painted chamber gives the impression of modern decor. The background is a deep brick color. Most design here is vertical with irregular stripes. The stripes are ochre with angled black, white and vermilion lines in a herringbone pattern. Black vines twist upward along the stripes and there are occasional streamlined birds. The frieze is ochre with vermilion and white dots to outline the swags. Use of color throughout this chamber is dramatic. The palette is limited to the brown-red brick color of the background with design painted in black, white, ochre and touches of vermilion. Birds are mostly in black, sometimes starkly outlined against the background with occasional startling white highlights. A few birds in one section are sketched in white alone. The wall painting in this room is not carefully measured and precise, like the work of the Scroll Painter, and the irregularity adds to its charm. The present owner of the house suggests that this chamber proves a point that legend has kept alive for years, that itinerant painters were vagabonds who liked to "hit the bottle." Perhaps the painter was only tired, or hurried, or both.

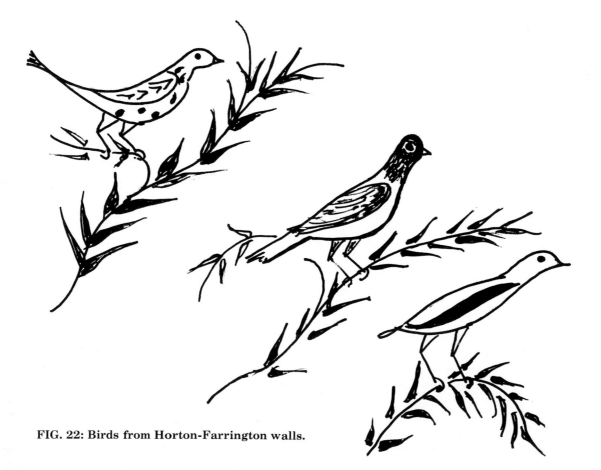

FIG. 22: Birds from Horton-Farrington walls.

WALDO HOUSE—South Shaftsbury, Vermont, circa 1770

The Waldos were pioneer settlers in South Shaftsbury, Vermont. Abiathar was born in 1735, served during the Revolutionary War as a captain of his company, and married a woman named Rachel. Both husband and wife lived long lives, dying in 1820 and 1821, each at age 86. Their home, sitting on a knoll looking down on Route 7 near Shaftsbury, is the type often referred to today as "Cape Cod." Within the past few years the home has changed hands and is being restored.

During restoration, wall painting was discovered in a front room which could originally have been either a parlor or a bedchamber. The painting is on deep-blue-painted plaster. Although the same painter decorated the three Vermont houses discussed in this volume, decoration in the Waldo House is less complex than that in either the Galusha House or Judge Horton's home in Brandon. The palette, for instance, is limited to only two colors, vermilion and white. The pattern is all-over, from floor to ceiling, without the intricacy found in the nearby houses. Also, the multiple borders seem to be absent. However, since walls

here were in need of considerable patching, especially around door and window frames and above baseboards, this repair may have covered borders around lines of construction. In the all-over pattern, vines or stems are white. Some of the main stems look as if they might have been afterthoughts, as connections between sprigs of foliage appear awkward. Portions of the stem are straight, in contrast with the gentle curves created by the Scroll Painter. Pairs of leaves, one on each side of the stem, are in alternating colors. Shapes and placement of leaves are characteristic of the Border Painter, although only one border is still visible, following a door frame. This border is simple, made up of large white strokes with smaller black ones lying inside their curves; every other set of these brush-stroke motifs reverses direction.

The choice of color scheme in the Waldo home is a fortunate one. The vermilion and white strokes contrast effectively with the shade of blue used as a background; the overall effect is appealing (Pl. 27).

GALUSHA HOUSE—South Shaftsbury, Vermont, 1783 and 1809

Jonas Galusha (1752-1834) was a farmer and innkeeper. A captain in the Vermont militia, Galusha served during the Revolutionary War and fought at the Battle of Bennington. He served as Judge and Sheriff in the local government. At the state level, he became a member of Vermont's Council and of the General Assembly. From 1809 until 1813 he was Vermont's Governor.

The Governor Galusha Homestead, as it is known today, consists of two parts which were bolted together, the first section finished in 1783. In 1809 Galusha contracted with a well-known architect, Lavius Fillmore, who had moved from Connecticut to the Shaftsbury area, to construct a two-story addition to his farmhouse, making it the elegant Federal home which stands today along Route 7 near Shaftsbury. The Homestead has elaborate architectural features: a detailed cornice, shaped lintels, lights on either side of the front door, round columns on the porch, and a Palladium window, the latter a reminder of earlier Georgian architecture. Interior as well as exterior woodwork shows painstaking touches exemplified by the inset panels and dentil molding surrounding the fireplace.

The house has been carefully maintained over the years since it has been occupied continuously, for many years by members of the Galusha family. Original wall painting remains in only one upstairs chamber, although at least two chambers were ornamented by the decorator. One, once covered with layers of wallpaper, has been repainted by a member of the Galusha family using tracings from the original wall. Interestingly, the downstairs front hall was once stenciled. Did the same decorator use both techniques in this house?

The original brush-stroke painting which remains decorates a wall covered with light gray paint (Pl. 28). There is an overmantel painting featuring a vase with flowers, and the whole chimney-breast is framed with a brush-stroke border. This overmantel treatment resembles that in a chamber of the Judge Horton House in Brandon, Vermont. Numerous border designs follow the lines of construction, over the chair rail and over the baseboard, along door and window frames, and at frieze level. The Border Painter was busy here with his characteristic repeating motifs, this time on bands of golden yellow. The overall pattern is a fantasy of color, vivid against the gray walls. The design again consists of flowers and foliage. Stems and vines are black and there are frequent black accents throughout the design. The pattern below the chair rail is different from the pattern above.

The wall of the chamber bears a strange scar, a plaster patch without design, about the size of a rectangular, medium-sized suitcase. The explanation? The piece was cut out and removed—by a house guest!

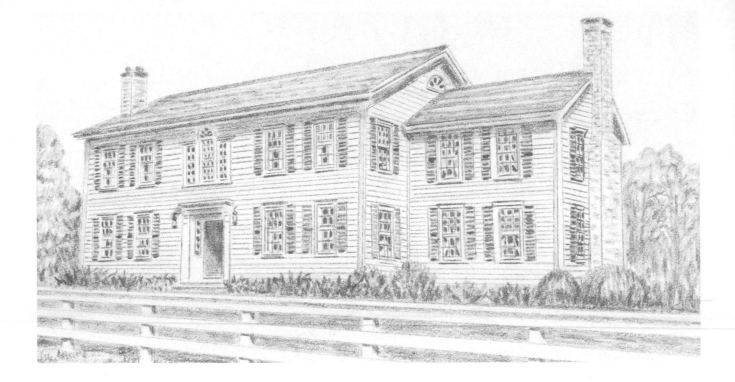

BAME HOUSE—Kinderhook, New York, 1816

Our old taverns, cropping up where turnpikes met and ferries crossed a river, served both local folk and travelers. The tavern was the first gathering place where news was exchanged and meetings were held to determine civic, political, and military matters. Traveling lecturers held sway at the inns, the itinerant justice held court there, and mail was left on the tavern doorstep before post offices were even considered. Weddings were held at taverns and the upper hall expanded to become a ballroom for the celebration. Auctioneers carried on their sales from the tavern's porch.

In *From Here to Yender*, Marion Nicholl Rawson wrote of taverns, "Upon their walls did the itinerant but purse-poor artist often pay his board and lodging in artistic coin..." It can not be pure coincidence that so many of the houses with brush-stroke-painted walls at one time served as taverns or inns. We know that this is true of the Stratton Tavern in Northfield and of the French House in Conway, both in Massachusetts. The Galusha House in South Shaftsbury, Vermont, served at one time as a tavern, as did the Dillenbeck home near Canajoharie, New York. The Chapin House in Chicopee and the Williams House in Sunderland, Massachusetts, were once inns. This was also true of the Ashbel Beach House in East Bloomfield in the western part of New York and perhaps of the Hudson House on the Old Albany Post Road near Malden Bridge, New York. None of the homes previously described in the Kinderhook area were known as taverns. There is another house, however, on Kinderhook's Old Post Road, which is large and has a row of bedrooms along a second-floor hall, the original doors of some still showing their old numerals. The house was a stagecoach stop on the Albany Post Road and possessed brush-stroke-painted walls, although not enough plaster has survived to illustrate them in this volume. The shards found under floor boards in the original kitchen by present owners Sharon and Bill Palmer show a background of yellow paint with a simple black-and-white brush-stroke border. This early home, which the owners believe was constructed in 1816, was first owned by Anna and William Bame.

Appendix: How-To-Do-It

Mural Painting

To my knowledge, there are no patterns available to imitate authentic early American murals. This allows the creative person with some training in painting to design his own scenes on tracing paper, transfer them to walls, and thus determine his own pattern in the old style. Jean Lipman's *Rufus Porter, Yankee Pioneer* provides for study photographs of murals both in black and white and in color. Porter's village and rural scenes abound with houses, rural vistas, and a variety of trees luxuriant with foliage. There are also harbor scenes showing ships in full sail.

Porter murals were originally painted in full color *or* in monochromatic shades of gray, umber, or gray-green. Japan paint is recommended for this style of painting.

Foliage is created by the use of a stencil brush which is pounced. (Pick a large brush.) A piece of sponge may be substituted as an applicator. Porter murals often had trees in the foreground and the varieties can usually be identified by the shape of the tree. Porter often used a dark stripe on one side of a tree trunk, a light stripe on the other.

Stenciling

For the person who has had little or no training in painting, stenciling walls is the easiest method for reproducing wall designs which look like the work of an early decorator.

Stencils may be made from waxed stencil paper usually available in craft or art supply stores. This often comes in inexpensive 18″ x 14″ sheets. Old patterns, or motifs adapted from textile patterns, may be traced on this paper and cut with a single-edged razor blade. Cutting should be done on glass to achieve sharp edges. Appropriate, ready-cut stencils are available at museum and craft stores. The best are made from waxed stencil paper or mylar. Avoid stamped-out metal stencils which are often too thick to give clean edges. A separate stencil is needed for each color applied.

Any type of wall painting may be done on old or new plaster or wallboard. Painting over wallpaper is not advised for best results. Water-based paint provides a suitable background cover. Be sure that the background has a matte finish rather than a glossy one. The decorating paint may be: Japan paint in tubes or cans; tube oil paint, which will take longer to dry; or flat wall paint, preferably from the heavy pigment at the bottom of the can. The texture of the paint, about the thickness of heavy cream, is what is important. Thin paint runs under stencils.

Paint should always be applied very sparingly. This may be done with a close-to-dry stencil brush (a stiff brush with bristles cut flat) or with a small piece of synthetic sponge. Openings in stencils may be filled in solidly as the old-timers usually did, or blended and shaded more artistically to give dimension, if that is the effect desired. One color should dry before a second stencil is placed on the design.

Some stenciled patterns on early walls go from baseboard to ceiling; some are above a chair rail only. Occasional patterns are limited to borders around lines of construction: along door and window frames, over a chair rail, at the top of a wall, over the baseboard. Frequently both borders and all-over patterns are used. Tailor your design to your own taste.

Thought must be given ahead of time to the placement of motifs. Measurements should be made and marked to insure advantageous placement of the pattern. If you wish to achieve an authentic look, study photographs in books such as Janet Waring's *Early American Stencil Decorations* or Nina Fletcher Little's *American Decorative Wall Painting*.

Brush-Stroke Painting

Authentic patterns for brush-stroke wall painting are not available. The adapted pattern included with this text is a suggestion, though, which you may try. Careful planning, measuring and marking of "frames" for a design can almost

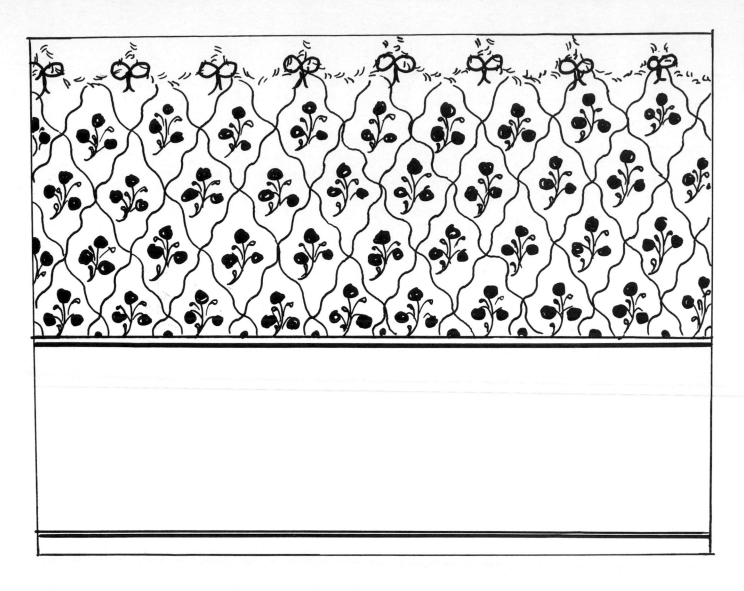

FIG. 23: Design above chair rail. (The latter can be real or painted.)

insure the success of anyone who can freehand paint one or two motifs to his own satisfaction.

Japan paint is recommended because it dries quickly, but not too quickly, as acrylic paint might. Use watercolor brushes for small strokes. Quills work well for base coats like those on the "ball" flowers (Fig. 24).

Remember that often brush-stroke designs are above chair rails only. If desired, a false chair rail can be painted on the wall and an all-over design plotted above it. Diamond or circle "frames" are recommended since these can be traced on the walls in an appropriate scale before painting.

These "frames" may be defined in wavy lines, dots, or clusters of two or three fine brush strokes alternating their direction. Design one or two motifs for centers of "frames," alternating them if you choose two different motifs.

A frieze will complete your brush-stroke-painted wall. Use a cardboard template to define the half circles. Bows between swags (Fig. 25) can be traced and followed exactly. The frieze may be done in a single color or a combination of two. You may make the frieze more elaborate by adding a motif of your own.

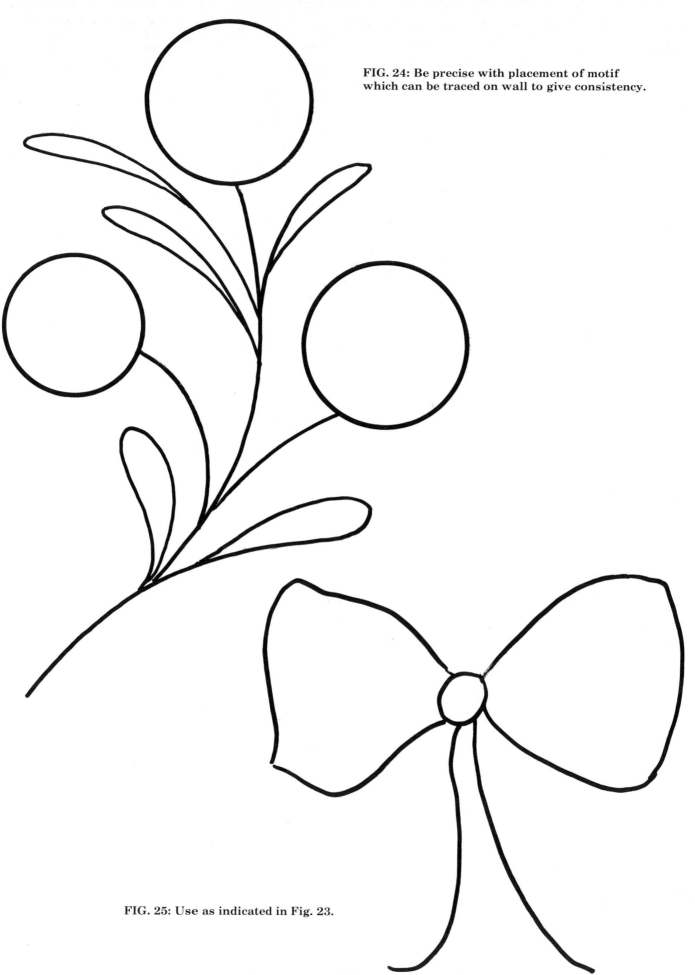

FIG. 24: Be precise with placement of motif
which can be traced on wall to give consistency.

FIG. 25: Use as indicated in Fig. 23.

69